On Curating //

Interviews with Ten International Curators

Interviews by Carolee Thea

Joseph Backstein // Carolyn Christov-Bakargiev //
Okwui Enwezor // Charles Esche // Massimiliano Gioni //
RoseLee Goldberg // Mary Jane Jacob //
Virginia Pérez-Ratton // Pi Li // Rirkrit Tiravanija //

edited by Carolee Thea and Thomas Micchelli

d·a·p D1379108

On Curating: Interviews with Ten International Curators

D.A.P./Distributed Art Publishers, Inc.
155 Sixth Avenue, 2nd Floor
New York, NY 10013

Editors: Carolee Thea and Thomas Micchelli
Production Manager: Todd Bradway
Design and Typesetting: Bethany Johns

First Edition
Printed and bound in China

Published by:

D.A.P./Distributed Art Publishers, Inc.
155 Sixth Avenue, 2nd Floor
New York, NY 10013

Tel: 212 627 1999
Fax: 212 627 9484
www.artbook.com

ISBN: 978-1-935202-00-4

Thea, Carolee.
 On curating : interviews with ten international curators / by Carolee Thea.—1st ed.
 p. cm.
 "Editors: Carolee Thea and Thomas Micchelli."
 ISBN 978-1-935202-00-4 (alk. paper)
 1. Art museum curators—Interviews. I. Micchelli, Thomas. II. Title.
 N408.T54 2009
 708.0092'2—dc22
 2009017924

Contents

foreword

A twenty-first century biennale will utilize calculated uncertainty and conscious incompleteness to produce a catalyst for invigorating change whilst always producing the harvest of the quiet eye.
—Cedric Price

The twenty-first century curator is a catalyst—a bridge between the local and the global. A bridge has two points, two ends. This is a metaphor for how one crosses the border of the self. One position, that of the original personality, will always be more stable, but the other, which is floating, is less stable; therefore the bridge can be dangerous. According to the artist Huan Yong Ping, this notion of danger is not necessarily negative but can be a creative force as it allows for the possibility of something else. And the possibility of enlightenment comes from embracing chance. Traditional Chinese philosophers never said *I say* but always said *our ancestors said* as a way of accessing reality. The curator should always be open to surprise so that the unexpected might happen. In a now legendary exchange, Sergei Diaghilev challenged Jean Cocteau to e*tonnez-moi* ["astonish me,"] when he asked him to write *Parade* in 1917.

The quest for a center of the art world dominated the twentieth century. The twenty-first century has opened to a polyphony of centers. Immanuel Wallerstein argues that as we travel from dreams that were betrayed to a world-system in structural crisis, which is unpredictable and uncertain, a new world-system will emerge that will inevitably go beyond the limits of the nineteenth century paradigm of liberal capitalism. The issue is not borders, but how to navigate the borderlines. Artists, curators and their exhibitions are nomadic, physically and mentally traveling across borders; by trespassing national borders, languages and cultures spill in all directions, expanding one's capacity for translation. To become a bridge or as Édouard Glissant says, "an archipelago." Biennales and other large scale exhibitions sometimes tend to be too much like continents, which are rock solid, and imposing, as opposed to the archipelago that is welcoming and sheltering. In Glissant's words, "The idea of a non-linear time implicit in this idea, or in this concept, the coexistence of several time zones would of course allow for a great variety of contact zones as well." The Biennale as a reciprocal contact zone can mediate between museum and city.

Twenty-first century curators use new spaces and new temporalities in order to achieve what Glissant calls *mondialité:* enhancing global dialogue. The practice of curating can learn from radical Polish urbanist and architect Oskar Hanson and his visionary concept for his Museum of Modern Art to question the often-unquestioned master plan. Curators invent new formats for exhibitions and architects must respond to them. As Hanson said in an interview with myself and Philippe Parreno, "We don't create these structures for formal reasons but to bring together the moral life with the physical life, since the second is obviously much longer than the first. Concrete, bricks, etc., remain, while functions evolve, the economy changes. For this reason, spaces must be capable of changing, of being continually recomposed."

This book is a wonderful example of curatorial polyphony in the early twenty-first century. Polyphony in music is the confluence of multiple voices, independent melodies woven into counterpoint. The curators in this book have internalized the urgency to generate a situation receptive to complex spaces combining the big and the small, the old and the new, acceleration and deceleration, noise and silence. To change what is expected...

—Hans Ulrich Obrist
Hydra, Greece
July 2009

On Curating //
Interviews with Ten International Curators

an introduction by Carolee Thea

Fearful consumers, you will all devour!
—William Shakespeare, *Two Noble Kinsmen*

The relationship between new artistic practices and new modes of production, new forms and new meanings—and the specialized economies they engender—cannot be considered without taking into account the recent transformations in the global markets. The exponential increase in wealth that produced a host of über-collectors and fund managers, whose pursuit of fine art bought them the joy of ownership as well as entrée into a privileged society, has suddenly shifted, and the effect of this newly precarious if not dire financial condition is unraveling with time. Already we see more and more artists turning the ordinary into novel forms, bringing to the forefront a more democratic structure for art practices and their social functions.

Among the major figures to have come of age in this cultural milieu is the independent curator, whose importance can be compared to that of the literary critic's in the 1950s or the business consultant's in the 80s. Yet, aesthetically, curators are more like theater directors, and it could be argued that they follow a performance paradigm rather than one based on the object or commodity. We could say they are translators, movers or creators whose material is the work of others—but in any case, the role of mediator is inescapable. While the art critic embodies the generalized gaze of the public, the curator inversely translates the artist's work by providing a context to enable the public's understanding. The expanding geography of the art world, the complexity and interdisciplinary nature of artistic proposals, and the demands of various publics create a situation in which mediation plays an ever more crucial role in the exploration and dissemination of art.

It has been my interest to interview those curators who represent or comment on the multiplying centers and hybrid activities articulated into their individual zones of scrutiny. Equipped with a rational understanding of the cultural moment as embodied in an artist's work, they utilize highly distinct strategies to expedite their role as conduit between the artist, the exhibition's institutional politics, and the public. These interviews, conducted over the course of six years, beginning in 2001, address the commonalities and differences among the curators' points of view, tracing a path into the 21st century and perhaps laying an aesthetic foundation that claims a measure of validity regardless of the vicissitudes of the marketplace.

The biennial or mega-exhibition—a laboratory for experimentation, investigation and aesthetic liberation—is where the curators' experience and knowledge are tested. As they negotiate venues for artistic expression, intellectual critiques and humanistic concerns in their own societies and others, they are challenged by the certainties and uncertainties of an evolving future. Through innovation and spectacle, they may also contribute to a host city's evolution into a transnational marketplace for elite consumers. At the same time, they take into consideration the critical shifts within the exhibition system and the aesthetic precedents that have defined our relationship to history and culture.

It was during the chaotic 1960s and 70s that Robert Smithson and Gordon Matta-Clark attempted to break the barrier between culture and society, innovating strategies that deconstructed the museum paradigm of viewing art. This 1970s imperative fueled the work of American independent curator **Mary Jane Jacob**, who is today considered a pioneer in the development of new forms of public art.

While at the Detroit Institute of Arts in the 70s, she organized numerous exhibitions that championed artists outside the mainstream, particularly those working beyond the so-called art center of New York. She also highlighted women and those employing experimental or non-traditional media. During the 1980s, she was Chief Curator of the Museum of Contemporary Art, Chicago, and of the Museum of Contemporary Art, Los Angeles. In 1990, she left the museum to work in concert with artists on projects conceived for locations where the audience interaction would be more direct, spontaneous and unpredictable. Opposed to art that functions merely on a symbolic or aesthetic level, her ambition has been to unite a community by commissioning artists to create installations that expand on the conventional story of a city's history. This has been the heart of Jacob's project: not entertainment for the post-capitalist city but an aesthetic, intellectual

and emotional transformation of the local reality. Her ideas and projects blossomed at the Spoleto Festival in South Carolina in 1991 and 2001, and she continues to elaborate her ideas in ongoing curatorial endeavors.

Admittedly, the ideas of Smithson, Matta-Clark and Jacob have been spread through the work of other artists and curators. In the forty-plus years that have passed, exhibitions are now presented in a variety of spaces—some on the skin of the museum, while others utilize architectural strategies, presenting gigantic sculptural constructions in vast atria and lobbies. Many of these spaces are so huge that they are capable of consuming the immense artworks originally created for the public arena, such as Richard Serra's 1997 work, *The Matter of Time*, in the Guggenheim Bilbao.

The rich audience component inspired by Jacob and espoused by Nicolas Bourriaud in his books *Relational Aesthetics* (1998/English version 2002) and *Postproduction* (2001) provides the aesthetic philosophy behind the Palais de Tokyo, a place for "installation" and "interactive" art that he co-founded with Jerome Sans. In Bourriaud's words, "The role of artworks is no longer to form imaginary and utopian realities, but to actually be ways of living and models of action within the existing real."

Rirkrit Tiravanija, Jacob's former student, is both an artist and curator. He believes that an artist curating an exhibition "always brings a different methodology and perspective." And like others today he has turned towards trans-disciplinary or collaborative practices to define new modes of bypassing formalist credos and bureaucracy—ones that interact with the social realities of daily life. Some follow Félix Guattari's philosophy, *ecosophy*, which includes the interrelationship of individuals to their cultural, social, economic and natural environment.

Born in Buenos Aires, he divides his time between New York, Berlin and Bangkok. Rirkrit believes that "It's not what you see that is important, but what takes place between people." His famous project, *The Land*, is a large-scale collaborative undertaking in the village of Sanpatong, near Chiang Mai, Thailand. Inspired by a holistic Buddhist garden, it's a new model for art, living and working as well as a laboratory for self-sustainable development. An inveterate journeyman who enjoys the challenge of complex situations, Tiravanija also co-curated the short-lived, politically censored first Ho Chi Minh City Biennial in 2007.

Another curator whose interest lies in testing the exhibition's conventional boundaries is **Charles Esche**, the curator and director of the Van Abbemuseum in Eindhoven. He believes that "The task ... is to move away from the reflexive form of art toward something more unstable and prepositional." He invokes Michel Houllebecq's term "metaphysical mutation" to discuss the need for "a new world order ... that challenges and replaces social and civilizational rules." For Esche, the "political moment" in art is not documentary or accusatory, but ambiguous and sensual; it ushers in an instability that enables viewers to effect a transformation in themselves and "to imagine the world other than it is."

For Istanbul Biennial 9 in 2006, Esche and his co-curator, Vasif Kortun, eschewed the seductive antique sites that were employed by past curators: Hagia Sophia, the Yerebatan Cistern and the Hagia Eireni Museum. Perceiving them as pandering to the dramatic, the focus instead was placed on the working city, not as the collusion of spectacle and marketplace, but as a place where art and artist could function in unexpected ways, expanding and facilitating encounters with both international visitors and local inhabitants. Viewers, some guided by a map of the sites and others by chance encounter, would discover a different kind of trove animating the living city.

Since midcentury, deserted buildings—the relics of the Industrial Age—have been converted into exhibition sites. This development has provided artists and curators with an urban equivalent of those desert expanses sought by the 70s land artists as an alternative to established art venues, as well as to create new, permeable environments in which the viewer is meant to participate. In a lecture I once attended, the speaker, Rosalind Krauss, described these spaces poetically as "a ghostly presence, grazing the surface and like an elsewhere, a paradox of being physically present but temporally anterior and locally exotic."

For **Massimilliano Gioni**, Ali Subotnick and Maurizio Cattelan, the curatorial team for the 4th Berlin Biennial in 2006, the choice to place the entire show on one historic street in Berlin was a spatial advance on Krauss' trope. *Auguststrasse* is made up of several streets that, before the Holocaust, were the marker for a Jewish neighborhood, encompassing a variety of surviving midsize structures: Kunst-Werke, once the home of a wealthy Jewish family that was used as a margarine factory during communist times; a former Jewish girls' school; a variety of small apartment buildings; a dance hall; low-rise offices; a playground and a cemetery.

The Berlin team layered the historical dimension with literary inspiration: the title, *Of Mice and Men*, was taken from the 1937 John Steinbeck novel, and the mood was gleaned from the Bavarian writer W. G. Sebald (1944–2001), whose novels speak of the struggle to rescue his memories of the apocalyptic aftermath of World War II from oblivion. Out of respect, the curatorial team agreed to preserve the historical resonance of the sites, what Gioni calls "fugitive voices," and treat the biennial artworks only as "guests." One could say that this gesture was a memorial highlighting the history of the city, but on a deeper level, its temporality befitted the site. Designed by the curators as an intimate theater of the absurd, the parcours began at the church and ended at the cemetery—passing through the spaces where our time is spent.

The curators also devised a temporal expansion during the two years leading up to the Biennial by starting a column in a local magazine featuring interviews with artists, thereby extending the tenure of the mega-exhibition and increasing its audience. As the founders of Chelsea's Wrong Gallery, they also engaged in what was termed "guerrilla franchising" by setting up a Berlin outlet for Wrong and rechristening it Gagosian Gallery. They followed this with an issue of their magazine, *Charley* (dubbed for this occasion, *Checkpoint Charley*), featuring the 700 artists whose works were viewed for the show.

Okwui Enwezor once said, "The biennial is an exhibition structure beyond itself, an event that allows for very difficult subject matter. Its function, as defined by planners and curators, is to add intellectual capital, to think about the relationship between the past and present and to experiment with truths." This statement, while having many applications, certainly pertains to the evolving curatorial perception of performance art.

Originally, performance art was considered against a background of a political and intellectual battle in cities across Europe, Japan and the U.S. It was a reaction to decades in which the traces of postwar trauma were slowly erased by expanding consumerism. As an extension of Dada and Futurist gestures, the artists deliberately blasted traditional art, forcing it into public confrontation.[1]

Today, when inserted into a biennial, often during the vernissage, performance is frequently viewed as a sideshow or a happening. The art historian and impresario **RoseLee Goldberg**, recalling the 60s and 70s art scene in New York City, where inexpensive downtown neighborhoods provided living and work space for artists, was inspired to found the biennial

1. RoseLee Goldberg, *Performance: Live Art Since 1960*, New York: Harry N. Abrams Publishers, 1998, p.37

PERFORMA. Now, after successful runs in 2005 and 2007, it has become a leading venue where, for a three-week period, performance art stars.

Goldberg's mission was to establish a much broader understanding of the role that performance plays in the development of artists' ideas and in the history of art. This New York City-based biennial provides a platform for newly commissioned material as well as revivals of early-60s and 70s performances. Of the latter, she has said that their "restagings do not necessarily deny the original intent of the work, but rather raise those earlier questions and force a rethinking." This activity has engendered a debate about the practice of restaging—whether it is a form of nostalgia, a variety of retro, or a reflexive celebration of a failed utopia. Some contend that by ignoring the context, it plays into a market mentality.

During the market boom of the past decade, art circulated at a growing rate, perfectly synchronized with the movement of capital and information. Ole Baumann, one of the curators for Manifesta 3, has said, "Don't save art, spend it!" Another, Anselm Francke, the curator for Manifesta 5, said, "Biennials are an optical instrument for showing wealth."

Artists and curators have been unavoidably affected by the onslaught of art fairs and consumerism. Some, like Charles Esche, who chose to focus on the transformative interactions of the biennial, seemed to anticipate the lean times ahead by privileging the audience over the object and by utilizing the working city's less seductive structures. Esche's work is viewed as a breach/investigation, meant to alter the trend of spectacle and engage the local population.

Carolyn Christov-Bakargiev, co-curator of the first Torino Triennial, however, claims to have no argument with the exhibition as spectacle or with corporate imperialism. She says, "I'm interested in how knowledge is constructed—to observe art on the micro level of a single artwork and see how it's negotiated in the world." Her approach recalls Harald Szeemann's words: "Artists are the best societal seismographs ... [they] work on their own, grappling with [their] attempts to make a world in which to survive ... and live [their] obsessions."

Christov-Bakargiev's selections of art for the Torino Triennial stemmed from the cultural structures in which an artist lives, which provide the work with a new level of understanding, irrespective of governing aesthetics and with respect to the past. This curator views her exhibition as a *decoy*:

a venture that allows artists, through their work, to parody, subvert or illuminate cultural assumptions. For her, each new exhibition can be regarded as a laboratory that informs strategies for new communities of discourse regarding the distinctions that decide what is *in* the canon or *not*. Christov-Bakargiev, who has experimented with curatorial inventions in the past, now believes that this practice has become ubiquitous to the point that it is no longer radical, but canonic in itself.

As for the confluence of the mega-exhibition and money, she explains that the exhibition/biennial "emerged from a democratic impulse," moving from the private exhibitions before the French Revolution to the idea of the public museum and, later, to the biennial. She believes that today we are in a conceptual decline that relates to the cultural legitimization of the art fair. A fall from grace (if you will), this demise can be traced back to ARCO, which began to feature avant-garde projects organized by a group of international curators. These types of projects and attendant panel discussions have grown to legitimize the congruity between art and the marketplace.

Co-curated with Francesco Bonami, this first Torino Triennial in 2006 reflected our out-of-control consumerist society. The title, *The Pantagruel Syndrome*, derives from a work by François Rabelais, a major French Renaissance writer who in his novel *Gargantua and Pantagruel* created the Pantagruel character: a peripatetic creature of gigantic proportions, power and appetites. He embodies the line between healthy desire and imminent, unbridled voracity—an apt metaphor for today's post-capitalist society. (Certainly the profusion of Murakamis in this Triennial is to the point.)

Globalization, brought about by technology and the collapse of world political and colonialist configurations, has systematically restructured interactive phases among nations by breaking down barriers in the areas of art, culture, commerce, communication, trade, labor and international migrations. The following curators, each from a different continent, discuss their approach to this issue.

Okwui Enwezor, curator of Documenta XI, was born in Nigeria and has lived in the United States for some time. He sees this post-colonial era as offering a model for rigorous thought in regard to the disjunctive and fragmentary aspect of our modern world, one that allows us the opportunity to look at contemporary art in a more complex way. It is his intention not to negate the vitality and necessity of the Western museum model but to task it to confront its own limits with imperatives not yet considered part of its general mission.

In his choice to focus on global transformation and post-colonialism, Enwezor employed the *documentary* as one mode of analysis. The exhibition's temporal and spatial regime, he believes, permits us to experience art and ideas "in the present without making an abstraction out of them or creating an undue ideological distortion." This approach, which overpowered the more conventionally aesthetic works in Documenta, was considered fraudulent by many of his critics and led to lengthy discussions in art-world journals. Enwezor's defense is that the documentary mode provides "greater access to … questions thrown by the unruly history of multiple traditions jostling for space beyond the ideology of neo-liberalism and capitalism." By "representing an excess of reality," it confronts the audience with "the unsavory elements of the abject in contemporary global culture."

Edward Said wrote that "culture works very effectively to make invisible and even 'impossible' the actual affiliations that exist between the world of ideas and scholarship … The cult of expertise and professionalism … has so restricted our scope of vision that a positive (as opposed to an implicit or passive) doctrine of noninterference among fields has set in." In this respect, I believe that the strategies in place at Documenta 11 to open the art-making and art-viewing process to the real world were an attempt to correct that narrowness.

Today, artists in the globalized art scene have been repeating a diverse and politically correct discourse about the disappearance of borders and trans-cultural crossovers. Some have experienced voluntary or forced economic or political migration. A perusal of recent biennial catalogues reveal that many artists in these shows are now settled in countries other than that of their origin. In this context, divisions between center and periphery, high and popular, primitive and contemporary, would hold the same validity. And today, the multiplication of biennials on a worldwide scale is one of the striking examples of this shift toward a supposedly more diverse and open scenario.

The critic and curator Michael Brenson has emphasized the importance of curators being as philosophically and spiritually connected to the international scene as they are to their own countries, taking on the multiple roles of diplomat, aesthetician, economist and critic. They must be conversant with artists, exhibition officials and community leaders, and the art they choose should stimulate dialogue about cultural transformations and global movements. For Viktor Misiano and **Joseph Backstein**, Deputy Directors for Contemporary Art at the State Center for Museums and

Exhibitions ROSIZO, in Russia, these traits had to be especially honed. Their collaboration and concentrated skills led to the first Moscow Biennial of Contemporary Art 2005, *dialectics of hope.*

Backstein and Misiano, along with four international curators, had their work cut out for them; in Russia, there is no museum for contemporary art and the art education system is so conservative that it still maintains a Soviet infrastructure. These directors struggled for more than a few years to convince the Ministry of Culture to give them a budget of 2.5 million dollars to host an international biennial. Backstein said that a major goal of the curators in the planning of the Moscow biennial was the modernization and legitimization of Russia's contemporary culture. "Visual art is an international language, and to organize a biennial [in Russia] means that the country/society has to become more tolerant, democratic and civilized. Biennials are a means of globalization," said Backstein. "Having once been an isolated superpower ... a show such as this means reintegration into the global community."

After decades of cultural isolation followed by trans-cultural crossovers, the discourse of the development of post-colonialism and globalization theory in curatorial practice and in art itself can be dangerously homogenizing. Of this, Backstein said, "The biennial is another way to present Russian art in an international context and present international art in the context of contemporary Russian art." He believes that this can be done "without destroying the local myth." The question for him is instead, "how do the global and local connect?"

Backstein further elucidates the Russian problem of identity: the founding of the Soviet Union on Marxism, a European philosophy, is at odds with its isolation from European culture under Stalin. It is a particularly Russian problem, one that doesn't affect a decidedly non-Western communist country like China.

China's artistic world, even before Mao Zedong, had only a small connection to the West—shared mostly by the intellectual elite who, along with high school graduates, during the Cultural Revolution were sent to farms and deserts for "re-education."

The end of the Revolution in 1977 and the rise to power of Deng Xiaoping were perhaps the most important political events in Asia in the second half of the 20th century. Within a few years, we saw the advent of contemporary Chinese art. China also began important trade and domestic reforms, but

these were interrupted in 1989 by the Tiananmen Square crackdown; it would be two years before the economic restructuring resumed, which re-ignited an amazing creative and entrepreneurial spirit.

For the curator and critic **Pi Li**, the son of an art historian at Beijing Central Academy of Fine Arts, the 3rd Shanghai Biennial in 2000 was a benchmark: the first of its kind to include both global and Chinese contemporary art. Since then the government has incorporated contemporary art into its cultural programs, employing Pi Li and other professional curators, but it soon became clear to them that such exhibitions served primarily as propaganda and were often censored. Consequently, while continuing to curate these shows, he and a partner opened a commercial gallery. Creating a duality of enterprise connected to the meteoric rise of Chinese art on the international scene may seem like a conflict of interest, but it could be said that China is forging new rules for old Western games. Its mushrooming interest in art rises hand in hand with a desire to be in the lucrative loop.

At the time of this interview in 2006, Pi Li was co-curator for Media_City Seoul. Titled *Dual Realities*, this biennial, hosted by Seoul, South Korea, is a public event that seeks to integrate new technologies with contemporary trans-disciplinary art. Of this event, Pi Li said, "Most Asian cities consider media or digital art as a new creative industrial/commercial movement," and he conceded that "Samsung, Sony and other computer companies sponsor artworks as a form of advertising." He also cautioned that "the convergence of art and technology has brought a danger to art, as the viewer's attention shifts to technology and odd visual experiences, and the artist's technological requirements come to obscure his conceptual and critical agenda." Pi Li has since given up all outside curatorial jobs to concentrate on his Beijing gallery, now called Boers-Li.

In Latin America, as in other regions, the pressures of globalization have exacerbated the need for new contemporary art events and exhibition venues, but the lack of traditional institutional infrastructures has led to more flexible, self-supporting and inventive solutions to foster new communities. **Virginia Pérez-Ratton** has developed such an experiment in Costa Rica, TEOR/éTica. A small space with a small budget and large purpose, it has become a cultural center in San José, with exhibitions inside and outside the venue. There is an arts library dedicated to contemporary art, design, photography and architecture. The reading room is open to all, six days a week, and its archive houses digital images, print reproductions and slides of Central American and Caribbean artists. As Pérez-Ratton puts it, "We

are in an age of multiple centers, and due to frequent travel, communication and exchange of images and information prompted by the Internet and other media, the relationship between localities is becoming increasingly interactive."

TEOR/éTica fills a much-needed purpose. Art education in Costa Rica is dominated by European and North American models, and courses in art and art history are from the 1950s. There is a new generation of artists in Central America, however, that is more informed, employing strategies of any international artist, but with a strong relationship to their own social contexts.

Pérez-Ratton does not formulate a strategy around identity; instead, she wants to "change the stereotype of Central American art that was once considered exotic" (notwithstanding Costa Rica's population of 7 percent indigenous) and to "integrate our artists into a larger circuit; taking the Costa Rican artist outside of the comfort zone and to promote exchange with foreign artists." To this end, after seven years under Pérez-Ratton's directorship, TEOR/éTica has organized *Estrecho Dudoso (Doubtful Strait)*, a large-scale event with more than 70 artists from 28 countries. This takes place across several institutions, public spaces and other venues in San José and Alajuela.

Propelled by the increasing number of large-scale exhibitions, certain developments irrespective of the markets have emerged around the explosion of interest in contemporary art. It is not enough for contemporary art to become a spectacle embraced by cities and people in all corners of the world. What matters more is that artists and communities are sharing information and mingling cultures at a rapid pace, reinventing themselves through these interactions and through a renewed engagement with the commonalities of everyday life. Cyber-communications and technological innovations may be accelerating these transmutations, but where they will lead continues to unfold before our eyes.

Cao Fei, *A Mirage (COSPlayers Series)*, 2004. Courtesy of the artist and Lombard-Freid Projects.

CT: An issue engaging today's curators of biennials is the discovery and exhibition of artworks from emerging and diasporic communities. One could say that your concept of traveling art from one community to another (by train) in 1975 presaged the current inclusiveness of non-mainstream art at the same time it challenged assumptions about the audience for contemporary art.

You could have easily followed a career in museums, working within established conventions. What were your personal motivations for doing this?

MJJ: I grew up in New York City, a place with great access to many museums and cultural events. When I traveled around the country, however, I found my experience wasn't the norm, and I became obsessed with how to bring rich encounters to other places and people.

When I curated my first project, *The Michigan Art Train*, I was a graduate student interning for the Michigan Arts Council. Using a six-car train, we traveled the countryside stopping in one location per week. Here a community audience walked through the train, feeling a new spirit and acknowledging the value and accessibility of sharing the art. It was art for the public.

CT: Hmmm, a way of having a temporary museum; it was an innovative strategy.

MJJ: Yes, it showed there were other ways of sharing and recognizing culture. One factor was to acknowledge what was already in place: not having to import art, but to look at the culture and resources of a specific locale. This was consistent with the hybrid activities of the time: facilitating new definitions of traditional forms that paralleled social and political upheavals.

It was a ripe moment for ushering in new audiences to participate in what had been considered an elitist experience. What people say about their places and values is often publicly submerged; the way I work allows for an easier evolution into the mainstream. Visiting the train, for example, gave the audience a moment to reflect—but not through eyes blurred by an esoteric dialectic. The idea was about perception—of our own lives as culture and history.

CT: Your strategy included new audiences, and also gave equal respect to women and to regional artists.

MJJ: When I curate shows, it is to add value and insight to a place and to social issues. Monuments and ancient temples have always been with us, but newly heightened factors propelled public art into the locus of discussion: expanding in space and time outside the museum, as an exercise for artist and audience to connect in the present moment.

My interest in public art became official in 1990 when I left the museum in order to work in partnership with artists on projects conceived for certain

/ Mary Jane Jacob

(previous pages)
David Hammons, *America Street*, 1991.
Courtesy Mary Jane Jacob and John
McWilliams, McClennanville, SC.

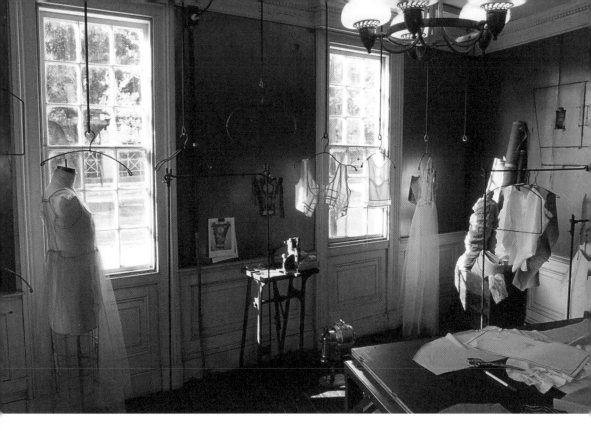

locations—most significantly in 1991 for the Spoleto Festival in Charleston[1]. It was here that I found an embracing discourse in public art: one that moved away from the monument/historical formula, or the contemporary masterpiece—like an Oldenburg or Calder—toward installations and process. It was art that brought dialogue through an incitement of memory.

CT: Yes, it's about expanding the discourse of public art, not simply expanding genres. Going outside the museum, you have the possibility of encountering a more diverse audience interaction, and to look at and think about a place differently.

MJJ: A communal experience can also be a shared silence on a public street; it can propel a dialogue that extends beyond the art object. This is what public art can do—when you think about the public as much as the art.

CT: Do you carry on your practice with institutional support?
MJJ: Yes, and it is directed toward programming—reshaping it with respect to the audience and the artist's work and making the institution as mutable

1. "Spoleto Festival USA was founded in 1977 by Gian Carlo Menotti, Christopher Keene and others involved in the Festival of Two Worlds as the American counterpart to that festival held annually in Spoleto, Italy. A Pulitzer Prize-winning composer, Menotti began the Italian festival in 1958 as a forum for young American artists in Europe. The festival quickly became a haven for a large group of artists, both traditional and experimental, who found the mix of dance, theater, opera, music, and the visual arts to be both exciting and stimulating." (Spoleto Festival USA website, http://www.wspoletousa.org/about/)

/ Mary Jane Jacob

J. Morgan Puett, *Cottage Industry: Thomas Carrol Cut Room and Shop*, 2002. Courtesy the artist.

as possible. A lecture or wall label may be among our tools, but my goal is to reunite a neighborhood through the living manifestation of an artist's ideas—ideas that would otherwise look solely symbolic, aesthetic or contrived.

I often return to a rudimentary definition of an artwork—as something that makes us see the world differently. The best dialogues I have are with people who don't have art degrees, those without preconceptions about art. They're open to my practice and will often say, "I don't know anything about art," but then find themselves talking about art in ways that are very meaningful.

CT: That fortunately turns received opinion on its head.

MJJ: Yes, we are often talking to ourselves or stratifying our experience as professionals—people with art degrees, with money—those from privileged social and economic circumstances.

My inspiration comes from Lewis Hyde's book *Trickster Makes This World*, where he speaks as a cultural critic, describing the mischievous *trickster* as one who articulates the living legends—and by *greasing* these memory joints of society, makes them flexible to the innuendos that history presents. For Hyde, and for me, the artist is a *trickster*, but the curator can play this role as well.

CT: Now that the Information Age has replaced the Industrial Age, many cities are left with deserted buildings occupying large, once economically forceful arenas. Where some cities have embraced their antiquated structures as alternatives to museums, others have built new signature edifices, such as the Guggenheim in Bilbao. Today, in the spirit of revitalization, touristic concerns are paramount, and I think it's safe to say that moving the Spoleto Festival to Charleston had a touristic charge.

MJJ: Yes. For one hundred years after the Civil War, Charleston lay fallow. It only began to come back after 1968. Then in 1977, Gian Carlo Menotti brought in the Spoleto Festival as a revitalization—to encourage tourism and other engagements.

But what we're doing with this visual arts program isn't only about tourism. We're benefiting from a strong cultural base that provides the latitude for art to act as an investigative tool.

CT: Charleston is quite distinct in its economy, geography and special history as a famous seaport and slave market. Do you think that, with this dark history, it could serve as a model for other communities?

MJJ: Yes. There are lessons learned in these projects that can inform how we proceed in our work collectively. As a curatorial body, we're not just keepers of collections; we're inventing processes to bring about works/exhibitions and programs as a public art form.

When I began working in Charleston for a show in 1991, it felt wildly

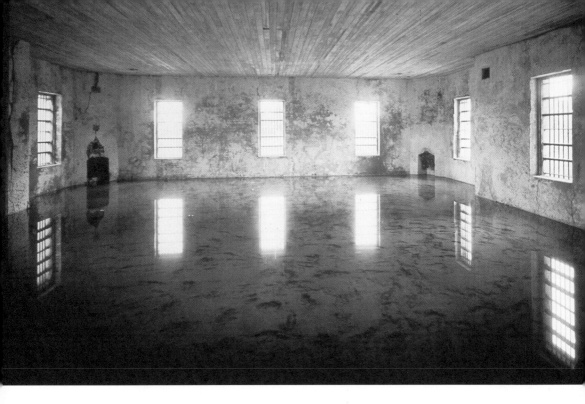

expansive to be outside the museum, connecting to individuals in the community and creating projects made specifically for them. Frankly, I was not fully aware of what I had ventured into. When I was invited back in 2001, it seemed as if all I could do was duplicate the previous dialogue. However, at the opening of the second show, *Evoking History, Part 1*, many residents recounted in extraordinary detail how the works they had seen in my earlier show affected them.

CT: Who were some of the artists in that first show?

MJJ: The 1991 exhibition, *Places with a Past: New Site-Specific Art in Charleston*, dealt with those historic sites and included the artists Christian Boltanski, Chris Burden, Antony Gormley, Ann Hamilton, Elizabeth Newman, and David Hammons.[2] There were twenty-three artists and eighteen installations, most placed in historic indoor or outdoor sites.

CT: Was your work informed by other models, such as Sculpture Park in Munster in 1987?

MJJ: Indeed. I was particularly interested in the site-specific work by Rebecca Horn, which dealt with the forgotten histories of Munster, and as such attracted a wider local audience. The locals had a lived historical

2. "Hammons was commissioned to create a large-scale assemblage of objects gathered in Charleston that would explore the African-American experience.

[Charleston contractor Albert] Alston's idea was to build a 20-foot-long, door-wide, two-story single house that would incorporate various styles of Charlestonian architecture. The different styles, materials and construction methods would be labeled. Inside would be drawings and paintings of objects appropriate to the themes of the piece by local artist Larry Jackson.

On the corner opposite the miniature house would be a small park, the centerpiece of which would be a Black Nationalist flag flying atop a 50-foot-tall flagpole. A billboard to the left of the flagpole would depict the faces of black youth with eyes lifted toward the flag. The back wall of the miniature house would be emblazoned with the words: '*The Afro-American has become heir to the myths that it is better to be poor than rich, lower class rather than middle or upper, easygoing rather than industrious, extravagant rather than thrifty, and athletic rather than academic.*'" (John Vernelson, "Spoleto: Behind the Scenes," *SC Progressive Network*, http://www.scpronet.com/point/9605/p13.html)

Antony Gormley, *Sculpture for the Old City Jail, Charleston: Learning to Think, 1991*. Courtesy Mary Jane Jacob and John McWilliams, McClennanville, SC.

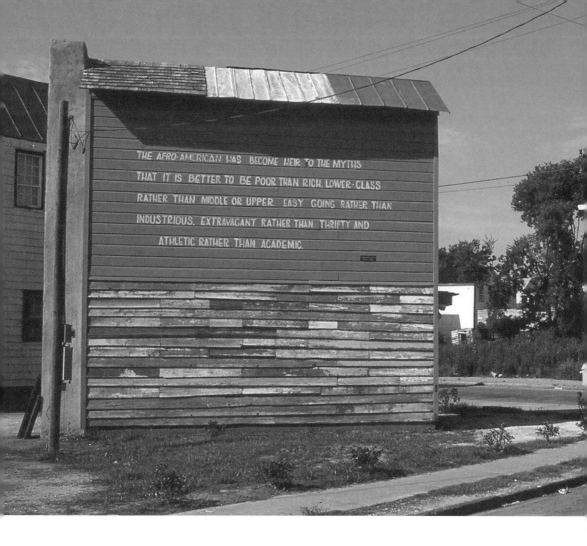

entry point, and they, not just the art historians, were the experts. History is our past and our present, and through art we recognize its vitality. The public isn't scared away from this, and through it they encounter their own lives.

CT: In the 90s, the demise of the National Endowment for the Arts[3] in the United States was brought about by its innate philistinism. Today, however, the current tax structure enhances/encourages philanthropic funding of the arts and, it seems, has temporarily filled the void.

MJJ: We have studies and proof of the economic development-value brought by galleries, real estate,

3. "The National Endowment for the Arts is a public agency dedicated to: supporting excellence in the arts, both new and established; bringing the arts to all Americans; and providing leadership in arts education. Established by Congress in 1965 as an independent agency of the federal government, the Endowment is the nation's largest annual funder of the arts, bringing art to all 50 states, including rural areas, inner cities, and military bases." (The National Endowment for the Arts website, http://www.nea.gov/about/index.html)

/ <u>Mary Jane Jacob</u>

tourism and philanthropy, but that's not enough. Our root questions are: why does art matter and how does it have essential resonance and relevance?

CT: Yes. It's an important dialogue.

MJJ: If we can't work across conventional social boundaries with our production and discussion of art, then we've been working in a restrictive way.

CT: I'd like to compare your ideas with those of James E. Young, who examines the stages of memorialization as they have played out in design competitions in Berlin for Germany's national Holocaust memorial. Professor Young looks at how the vernacular of memorials has changed—how the very idea of the memorial has evolved from older, passive monuments in which memory is lost inside the material object. He based this on the observation that many monuments are less prompts for thinking about complex historical situations than expressions of a completed and sometimes one-dimensional interpretive process. While monuments do highlight historical connections, they can never replace public and individual responsibility for critical recollection and remembrance.

MJJ: Yes. Young's ideas are a reflection of major issues addressed in the contemporary debate on monuments, and thus of the quality of public historical awareness. One of the reasons public art has changed in the last thirty years was the need to expand beyond the traditional monument model where the patina has obscured relevance. Perhaps that kind of art doesn't speak to us anymore; maybe it never did. What's different about Charleston is how it has moved the discussion forward to embrace the city as a living memorial to slavery—and to the problematic economic relations that built this society.

For six months, in weekly workshops in Charleston, the southern writer Neal Bogen worked with nine artists, architects, and poets discussing the nature of monuments, demographics and real estate relationships. This was a great influence for the artists assigned to the Festival's *Memory of Water–Memory of Land* project in 2002. Among these artists were J. Morgan Puett, Nari Ward and Yinka Shonibare.

/ **Mary Jane Jacob**

David Hammons, *America Street*, 1991.
Courtesy Mary Jane Jacob and John
McWilliams, McClennanville, SC.

CT: Then, in your lexicon, it is clear that a *memorial* is an activity instead of an object.

MJJ: We're working with living monuments to commemorate ideas and actions that continue to be present. Barbara Kirschenblatt-Gimlet, one of our national stakeholders, made a distinction between the *Lieu de Memoir* and the *Milieu de Memoir*. The former being the man-on-a-horse type of thing, where a statue commemorates the event. The *Milieu de Memoir,* on the other hand, is a memory-prod to places where memory continues in the actions and consciousness of people in the present. Our mission is to deal with living memory as an important channel for change.

In 2000, Nigel Redden (the director at Spoleto) encouraged us to undertake an exhibition that would create a memorial to the *Middle Passage*.[4] In his introduction, he said this could be hypothetical, temporary or impossible. His thinking was truly expansive and unconstricted— and frankly, none of us could imagine where it would end up.

We found that our preconceptions about monuments and symbolic memory were outmoded. New ones, which need to include living memory, should take another form. In this respect, this city has itself become a monument; neither to assuage the past nor to create something we pass on our way to somewhere else, but to create discussion.

4. "Middle Passage, so called because it was the middle leg of a three-part voyage—a voyage that began and ended in Europe. The first leg of the voyage carried a cargo that often included iron, cloth, brandy, firearms, and gunpowder. Upon landing on Africa's "slave coast," the cargo was exchanged for Africans. Fully loaded with its human cargo, the ship set sail for the Americas, where the slaves were exchanged for sugar, tobacco, or some other product. The final leg brought the ship back to Europe." ("The African Slave Trade and the Middle Passage," *Africans in America: The Terrible Transformation, Part 1: 1450-1750,* http://www.pbs.org/wgbh/aia/part1/narrative.html)

(facing page) Nari Ward, *Fortress*,
2002. Courtesy the artist.

Yinka Shonibare, *Spacewalk*, 2002.
Courtesy James Cohan Gallery,
New York.

/ **Massimiliano Gioni**
Interview 2007

CT: The monuments of industrial archaeology, abandoned office buildings among them, have often become the counterparts of the desert sought by land artists of the 70s. These artistic gestures were an attempt not only to turn us away from the established circuit of art institutions and museums but also to alter or permeate the existing environment and create a new one in which the viewer is meant to participate. Rosalind Krauss describes these spaces as a "ghostly presence, grazing the surface and like an elsewhere, a paradox of being physically present but temporally anterior and locally exotic." The strategy for the Berlin Biennial to place the entire parcours on one street was a spatial advance on this trope.

MG: In my work, I've often borrowed deserted edifices for an art project. In Milan, where I'm the curator for the Trussardi Foundation, I make use of public, private or otherwise unconventional exhibition sites for contemporary art. To adopt spaces where you still feel the presence of embedded history is compelling, and Berlin is a multilayered place where much of the architecture contains a legacy of stories, legends and memories.

CT: Obviously, street credibility was a high priority for your curatorial team. Berlin is known for its anti-institutional avant-garde scene, but was it the city's macabre history that compelled you to create this unusual form of exhibition?

MG: It was a combination of things. At first, we were offered the Martin Gropius-Bau, a very bourgeois middle-class building, but it felt wrong. Since there were many fascinating artists of our generation in Berlin, we realized that an institutional site like Gropius-Bau would be the last place these artists would visit. They see art in galleries, nonprofit spaces, certain institutions and especially in each other's studios. There are any number of spaces where Berlin artists catalyze different scenes and create their own structures in which to present work.

CT: This, the 4th Berlin Biennial, has been credited as a model for an intimate, experiential theater of the absurd, one that took place in venues including apartments, a cemetery, a former school, stables and the street. With the team of Maurizio Cattelan, Ali Subotnick and yourself curating one show, how did you reach consensus on the concept?

MG: First, we all agreed there was a certain tiredness with the model of the biennial as a global village. The original biennials were descendants

/ Massimiliano Gioni

(previous pages)
Nathalie Djurberg, *Viola*, 2006, still.
Courtesy Zach Feuer Gallery.

of national expositions, and 100 years later, Harald Szeemann resuscitated this with the *Aperto* in the 1980 Venice Biennale, a post-nationalistic model of a grand sprawl. Here, one could go from Chen Zhen to Jason Rhoades to Pipilotti Rist to Mike Kelley as if inside a transnational community where it was possible to skip from one place to another at the speed of the Internet. Maurizio, Ali and I were tired of that model; it didn't belong to us. We were inspired by *Auguststrasse*, the street on which sat the Kunst-Werke and the Jewish Girls' School. It was a new spatial experience where, instead of sprawl, there would be a highly concentrated, fluid space. As there were national historical considerations and traumas here, it took two years for us to get the proper permissions; we knew we would have to overcome skepticism and the fear of opening up old wounds.

CT: How did you attempt to alleviate the council's mistrust and do a show in such a loaded environment?

MG: First you have to define what's political. As a curator, you're a diplomat, and the main thing is to listen to the voices of the artists and help realize the exhibition without your own politics getting in the way. Also, with the national status of such a biennial, to gain the city's confidence—especially in the Jewish community—took a lot of time and education.

CT: Of course, a large part of the curatorial mission is to understand what it takes to make something happen and, thus, to be a good negotiator.

MG: Sometimes it's boring, but this is important; if curators left holes in the budget, it would screw up the economics for the next show. We had to respond with efficiency to ensure the artist's and the institution's survival. Even the discussion about Gropius-Bau was a long conversation. Originally, we wanted to use other kinds of spaces prevalent in the 90s, like converted warehouses, but when we saw the girls' school and other structures on the street, our idea evolved to include the philology of a place—to amplify and preserve the fugitive voices already present—and the artwork we introduced would function as a *guest*.

CT: In 1984, Jan Hoet organized *Chambers Des Amis*, where artists were selected to make works inside different homes in Ghent. Here, too, the art had guest status.

MG: Yes, that was about domestic spaces where people still lived. For our show, most of the apartments we chose were empty. The subtext and theme for the show was loss, abandonment and surrender. When

(above)
Oliver Croy and Oliver Elser, *Special Models–The 387 Houses of Peter Fritz, Insurance Clerk from Vienna*. Courtesy the artist and Wien Museum, Vienna.

/ **Massimiliano Gioni**

you stepped into these places, you knew someone had been there before and something had happened, but you missed it.

To communicate the project concisely, I always try to find a synthesis; perhaps I learned that from Maurizio. Some say the single-street idea was a manipulation, but we believe that it was a way for the viewer to engage their imagination.

> CT: The title of this Biennial, *Of Mice and Men*, was an appropriation of an appropriation; you took it from John Steinbeck's novel, and he took it from a Robert Burns poem.

MG: Both the Steinbeck story and the Burns poem are about loss, surrender and the uncertainty of the future. Another common element bore upon people behaving like animals, and animals like people—such as when humans turn into beasts, e.g., the Nazis perpetrating the Holocaust. We also felt this title would bring people to a new place.

We made lists of hundreds of types of biennials that would be unique, ones we'd never seen before. Finally, we came up with a Biennial with no objects—just animals and people. At that point, we tried to radicalize, to go beyond this to the street and atmosphere, to where the first tensions emerged, and for this the title was perfect.

> CT: A book I read recently, *A Woman in Berlin: Eight Weeks in the Conquered City*, was written by an anonymous woman who lived in Berlin right after the war. She describes the people in her ravaged apartment building behaving like animals, scrambling to survive among the chaos, rapes, vermin, vandals and ruins.

MG: There is this Italian word, *sprezzatura*. It's about the ability to do something difficult in ways that don't reveal its complexity. It's also the principal behind Mannerism, where one executes an incredibly complex drawing with a lightness that masks the difficulty. In my work I always try to hide the intellectual references so as not to be obscure, but reading and research are very important. One source of inspiration was from a W. G. Sebald lecture, *The Natural History of Destruction*, in which he states that in Germany, the Holocaust was erased from the history books until the 70s. Germany never came to terms with its complicity and trauma after the apocalyptic Allied bombings of Dresden, where thousands perished and millions of flies swarmed the city.

In my catalogue essay, I mention another book, *The Master and Margarita* by Mikhail Bulgakov—about a Moscow that never existed, where cats speak and the devil flies.

Another influence, an American cult-classic road story, set in a small midwestern county, is *Blue Highways*, written by William Least Heat-Moon. In 1,000 pages, he paints remarkable portraits of the people living in each room of a tall building. His tales descend beginning from the top floor; instead of a sprawl, it's a vertical hyper-concentration.

/ Massimiliano Gioni

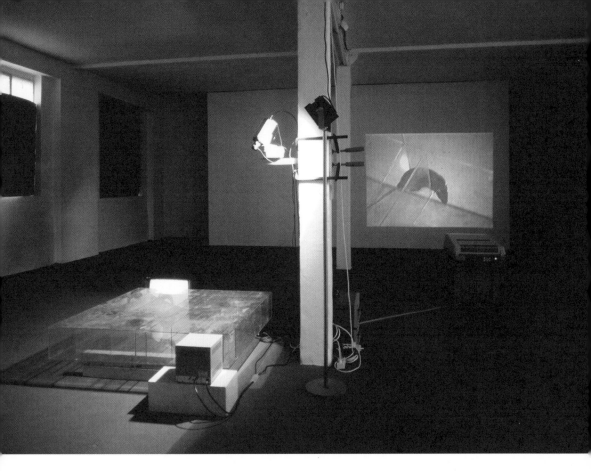

Then there's Giorgio Morandi, the reclusive painter who spent his life painting the same bottles over and over—a search for density and depth rather than mobility or multiplicity.

Inspired by the idea of density and anti-mobility, we traveled through Germany by train only, searching for artists we had never worked with before. We didn't include the Chinese, however, simply because we had to find our own voice outside of the global mentality. Our idea of using one street 920 meters long was cinematic—like a daydream or a movie. There is the idea of hyper-*pentimenti*, corresponding with the depth and density of research derived from Morandi or *Blue Highways*, which translated into one space going into many different spaces, like a mouse or a rat. It was also a reason for including Bruce Nauman's labyrinth.

Once we had the girls' school—an amazing place like nothing we'd seen— we knew it was right. The memories of Szeemann's Arsenale from the Venice Biennale, as a beautiful walk micromanaged to see one thing and then another, was inspirational. Our show was similar, but taken outside.

Bruce Nauman, *Learned Helplessness in Rats (Rock and Roll Drummer)*, 1988. Museum of Modern Art, acquisition from the Werner Dannheisser Testamentary Trust. Courtesy Sperone Westwater, New York.

/ **Massimiliano Gioni**

34

CT: The notion of site-specificity refashioned the idea of the journey by no longer confining it to the abstract gallery space. Through this, a form of domestic tourism was invented—one that renewed ties with the modern tradition of the flaneur and his fascination with the strangeness of the city and its slightly tawdry glamour. After the wall came down, *Auguststrasse* in Mitte was the first place of gentrification. Galleries appeared, and now it has become posh and hip. In terms of using it for your Biennial, there must have been skeptics.

MG: They all made fun of us. "It's the tourist area," they said. We assured them it would be amazing, and afterward, they understood the depth of our project. Our quest for authenticity reached the point that in the girls' school, wherever we drilled holes in the wall for artworks, the residue dust would be taken up so not to mingle the present with the past. It was a hyper-concentration where time became a crucial note, like the paper houses of Peter Fritz.

A guiding principal of the walk on *Auguststrasse* was, What happens to humans with time? The walk, beginning at the church, ended at the cemetery with Susan Philipsz's sound installation and passed though the

Susan Philipsz, *Follow Me*, 2004,
installation view at the 4th Berlin
Biennale, Old Garrison Cemetery,
Berlin. Courtesy the artist and Tanya
Bonakdar Gallery, New York.

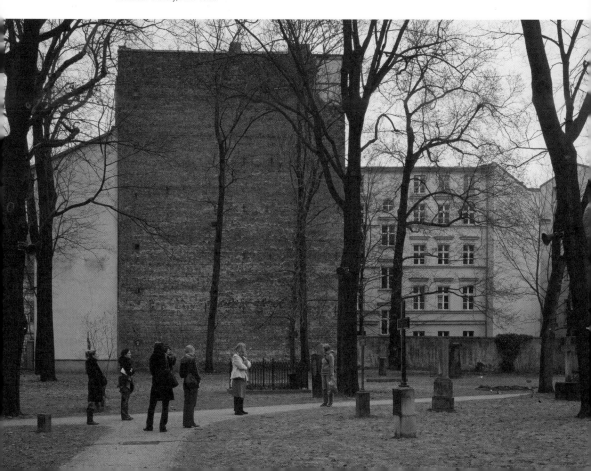

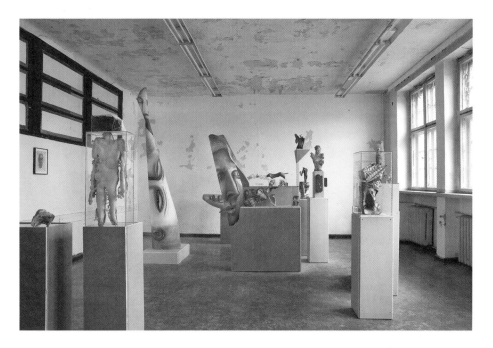

Matthew Monahan, *Twilight of the Idiots*,
1994/2005. Courtesy Anton Kern
Gallery, New York.

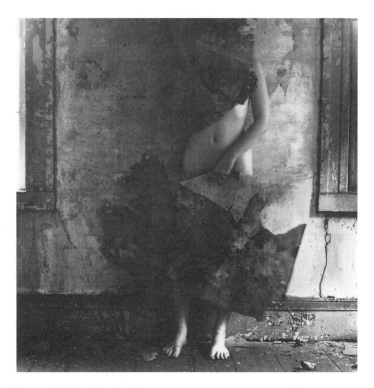

Francesca Woodman, *from Space2,*
Providence, RI, 1977. Courtesy The
Estate of Francesca Woodman.

typologies where time is spent: church, school, factory, apartment—places where we pray, work, eat, play and die. Among the artists in the girls' school were Roland Flexner, Francesca Woodman and Rachel Harrison. Peter Fritz and Corey McCorkle were installed in the KW Institute for Contemporary Art.

We knew we didn't want to be as theoretically heavy as is typical in Germany, exemplified by the 3rd Berlin Biennial. Instead, our show would be a research about the city, perhaps because Maurizio is an artist and Ali and I come from backgrounds where literature and art would be the guiding principles.

CT: Did the three of you read the same literature and watch similar films and TV programs?

MG: Part of my role was to construct the intellectual framework, but we all shared the readings. Cattelan was reading *The Battles of Napoleon* and we all watched the same TV series—*24*. Our idea of unity was very important and we felt our work should be very tight and clear for the exhibition, to be like one experience. We also wanted the viewer to have the feeling of entering a world where the rules are different.

CT: Something like the *carnival*, a place where you can suspend traditional hierarchies and briefly subvert them?

MG: Well, maybe institutions too can disrupt the normal flow of things and then return to normal.

CT: How does the rise of creative industries reflect on the role of the artist and creativity in this first decade of the 21st century?

MG: Because art can produce so much wealth, the artist can get away with more.

Regarding the art market since 1999, when I thought it was going to crash, a work by Cattelan went for one million! It never crashed, but I do see a major change; the price now determines the quality, and this absurdity has the ability to monopolize every conversation. It's now the issue of the investment bankers who have made the audience bigger. Money has the power to change everything, and Jeff Koons has made the game even bigger. With rich new audiences, it is all happening through money.

CT: After the downward spiral of the stock market in 2001, people diversified their wealth into art not only as a commodity but also as an activity that carried with it social status, exclusive parties and art fairs, with or without the presence of the artist.

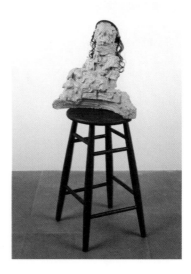

/ Massimiliano Gioni

Rachel Harrison, *Pink Stool*, 2005.
Courtesy Greene Naftali Gallery,
New York.

MG: Biennials are publicity machines, but the equation that *money equals evil* is wrong. Money is a tool. You could say that it's better to spend money on biennials than on weapons and wars. Furthermore, money and art have been in bed forever.

CT: Is that what you were thinking when you opened a branch of your own Wrong Gallery in the Biennial and rechristened it Gagosian Gallery?

MG: The Wrong Gallery[1] was originally born as a challenge to the Chelsea thing—it was about real estate and a space that operates at zero economy— a no-profit, no-budget space. But for a biennial, it's more interesting to accept the job as a curator and do it in a way that's unexpected, bending the system and giving voice to practices that were previously nonexistent.

For us, this 4th Berlin Biennial was a creature with many heads and different identities. Biennials happen every two years, and within that period we started a column in a local magazine where we interviewed artists. Then we started Gagosian Gallery, followed by an issue of *Charley*,[2] which included 700 artists whose work we had viewed. This two-year period of activities relating to the Biennial was very clear on a local level, but not globally.

CT: Why did you appropriate the name "Gagosian" for the Wrong Gallery here in Berlin?

MG: Actually, Ali invented the term *guerilla franchising*!

CT: Did you ask Gagosian if it was OK?

MG: Yes. He knew and thought it would be a one-time thing but was upset when he got the second invite. It lasted for one year. We live in an age of knockoffs, and to do a gallery as such was to challenge the provincial nature of the art world.

CT: Was it a non-profit space?

MG: It was a place to show works with a very small part of the Biennial budget. I'm interested in relations that are parasitic, so think of it as a sort of viral campaign. You know, we're not the St. Francis of the industry.

CT: The hierarchy has changed in the art world; it now seems that the collector is the apex.

MG: Yes, but it all points to the artist, whose role is the most important. He/she makes the commodities for collectors. The main actor of the 90s was the curator, and now it is the collector. The new model of the 90s was the biennial, and now it is the art fair. It goes in cycles, but without the artist, none of this exists.

1. "Since 2002, the team of Maurizio Cattelan, Massimiliano Gioni and Ali Subotnick has been running The Wrong Gallery, a miniscule exhibition space in Chelsea, New York's district.... Playing with exhibition formats and distribution tactics, The Wrong Gallery has also promoted small clandestine interventions in public spaces.... The team also publishes *The Wrong Times*, a newspaper that features interviews with all of the artists presented at The Wrong Gallery" (4th Berlin Biennial for Contemporary Art website, http://alt.berlinbiennale.de/eng/pdf/bb4_web_curatorsteam_cv_120705_english.pdf). 2. "Cattelan, Gioni and Subotnick also founded and co-edit the systematically inconsistent contemporary art publication series *Charley*, which is supported by the DESTE Foundation in Athens. A do-it-yourself combine, bound to change content and format at each and every appearance, *Charley* digests and processes images, artworks, articles and previously published materials, in order to reshuffle and re-interpret information" (ibid.).

/ **Massimiliano Gioni**

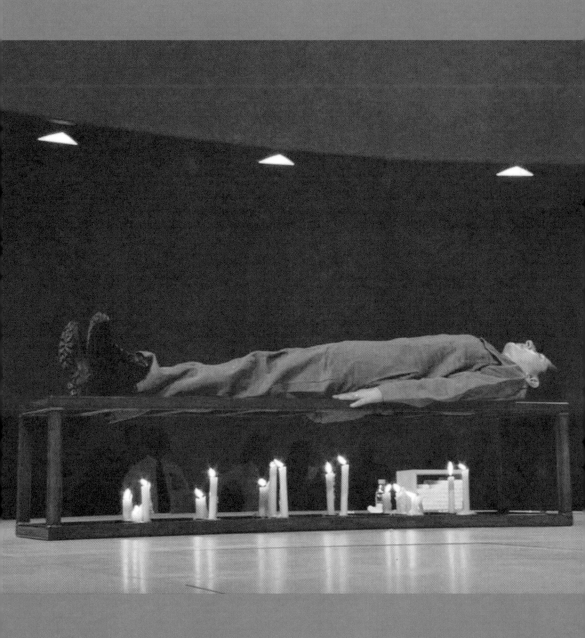

CT: One could say that the biennial is an exhibition structure beyond itself. It is defined by planners and curators whose role is to add intellectual capital, to think about the relationship between the past and present and to experiment with truths. It is an event, as Okwui Enwezor has said, that allows for difficult subject matter. What was your idea in constructing a mega-exhibition in a city already rife with cultural events?

RG: For me, the history of this particular art form is insistent. After three decades of writing about performance, my mission is to insert performance back into the history of art. The practice has either been overlooked or, as in the case of the international mega-exhibition, often presented as a sideshow.

After I visited Documenta XI, I realized I had to create something like PERFORMA. I remember trying to watch Isaac Julien's *Paradise Omeros*, and between the people milling about and my own confusion regarding its time span, I was frustrated and distracted. Later I heard about a Kentridge performance that evening, but I was too exhausted to go. Speeding through shows and fairs, one is never able to pay enough attention to all the artwork. Experiences like these gave me the impetus to slow things down and give each performance a dedicated space and time.

CT: It's true—performance at biennials is often presented as overture or sideshow, such as the 2003 Istanbul Biennial, when Surasi Kusolwong's *Thai Boxing* kicked off the festivities. At one Venice Biennale, Marina Abramovic's *Balkan Baroque* was performed only during the vernissage. Yet Tino Sehgal's work at the 4th Berlin Biennial continued during the entire course of the show.

RG: Certainly, performance will always be there, but I believe that within the next five years it will be much more developed and presented

Marina Abramovic performing *Gina Pane's The Conditioning*, first of three phases in *Self-Portrait(s)* at the Guggenheim Museum, 2005. From the film *Seven Easy Pieces*, directed by Babette Mangolte. Courtesy Sean Kelly Gallery, New York.

/ RoseLee Goldberg

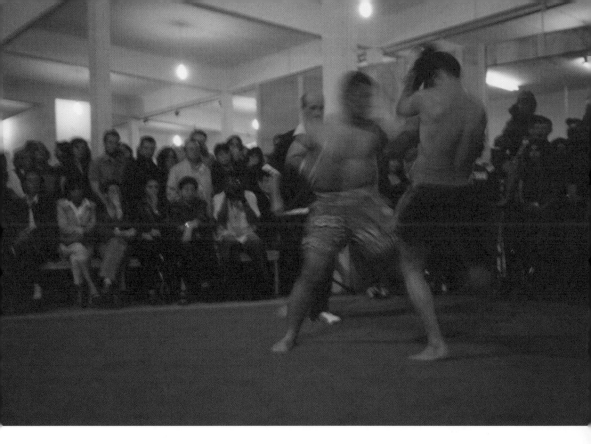

in venues that attract younger audiences who desire a closer relationship to the art and artists. For the occasional biennial, it's never well articulated or understood, and only a few people write about it.

CT: There are journals specifically dedicated to performance art.

RG: Yes, but the concept is not in the collective brain of those who look at contemporary art. Artists like Cindy Sherman, Rirkrit Tiravanija, John Bock, Andrea Fraser, Pierre Huyghe, Maurizio Cattelan and Tino Sehgal wouldn't be making the work they do without the knowledge of its history. As a compost heap of ideas that includes the Futurists, Dadaists and Surrealists, Rauschenberg, Oldenburg, Vito Acconci, Dennis Oppenheim and others, performance has shaped 20th-century art; however, it's rarely discussed in those terms. Up until the 70s, there was a time when artists used performance to investigate ideas before they made objects. That was where the real inventiveness began. Yet many art historians simply don't understand the significance of its origins. For example, in 2006 there was a Dada exhibition at MoMA, and the two people who started *Cabaret Voltaire*, Hugo Ball and Emmy Hennings, were missing. The *Cabaret*, founded in 1916 in Zurich, provided an arena for interactive artistic and

/ <u>RoseLee Goldberg</u>

(above)
Surasi Kusolwong, *Thai Boxing (Seen with the Eyes and Known to the Heart)*, 2003. 8th Istanbul Biennial. Courtesy the artist.

(facing page)
Issac Julien, *True North Series*, 2004. Courtesy the artist and Victoria Miro Gallery, London.

political ideas that proved pivotal in the founding of Dada. The works were often chaotic and brutal, mirroring the upheaval of World War I.

CT: In the 50s in Osaka, the performance group Gutai came together following the Japanese defeat in WWII, and in the late 60s, performance art instigated by social and political turmoil in the US attested to the form's endurance as an activist interrogation of the status quo. In 1971, to take one example, Dennis Oppenheim's *Protection* involved guard dogs blocking the entrance of the Metropolitan Museum of Art, a move that questioned the sanctity and elitism of museums. My fear is that certain works from this period, restaged today, may lead to a misunderstanding of social and cultural history.

RG: History shapes the way we understand all art. Performance needs an ongoing program that would allow for an intellectual critique to proliferate. It provides comparisons, but it is contingent on all the visual arts, not something separate.

CT: As an artist who began working in the 70s, I feel it is important to remember that parallel with agitating for political and cultural change, we were collapsing the formal aspects of painting and sculpture—advocating change through the creation of new forms.

RG: And today, the boundaries between disciplines have become so porous that it is almost impossible to separate them.

You asked why I would do a biennial in New York, a city so saturated with cultural events? It is about activating the city in another way. Coming of age in the 70s, performance slipped in from the bottom. Today, the galleries and museums are creating a marketplace that's top-heavy. Things don't bubble up from the bottom like they did in the 70s—visiting artist's lofts, wandering down to Battery Park or participating in Art on the Beach. The institutions never marshaled those events, and I believe it's important to provide that kind of underbelly of activity for three weeks. PERFORMA is helping to produce multimedia works not in museums but in various cabarets, venues and non-profit spaces. We don't want to exhibit in one institution, as it would become too standardized or restricted.

CT: You mentioned that Isaac Julien's new work, *The Ice Project*, is more of a performance than a film installation. Lets talk about this distinction.

RG: First of all, I don't look at work in terms of categories; I come from an interest in history, moving from *The Cabinet of Dr. Caligari* to Surrealism to painting to film. My own background as a dancer and a painter is certainly an influence; I've always been interested in crossing disciplines. My dissertation was on Oskar Schlemmer and the Bauhaus. Schlemmer was a painter, sculptor, master draftsman, performer, costumer and choreographer. I'm looking not just at artists who make performances but at works that are performance-related. The piece could start with the body and suggest performance, or it could be a film made from a performance; it's about moving across disciplines. Isaac Julien's *The Ice Palace* is a collaboration with choreographer Russell Maliphant, a lighting designer and a sound technician.

CT: With only six months' lead time, it must have been an enormous challenge to put together a world-class festival. How do you plan to secure the venues, not to mention the funds?

RG: With PERFORMA 05, I contacted curators whose work I found really interesting and asked them what they might present as part of a performance biennial. I further asked whether their organization would agree to carry the costs for that time period, as they normally would for their own programming. Everyone was comfortable with this, and essentially it came together in a collaborative spirit. With the financial support of a few amazing individuals, it was possible to put together an administrative staff. Also, with very short notice, the French, Dutch and Danish cultural organizations came on board.

PERFORMA 07 is essentially being assembled in a similar fashion. Having more time hasn't made that much of a difference because I find most of the artists today are working on multiple projects. With only six or eight months before the biennial, they are considering what to show.

/ RoseLee Goldberg

(facing page)
Janet Cardiff, *Münster Walk*, 1997. Audio walk with mixed media props, 17 minutes. Curated by Kasper König for Skulptur. Courtesy the artist, Luhring Augustine, New York, and Galerie Barbara Weiss, Berlin.

CT: Many early conceptual performances were fueled by an anti-materialist spirit, and they are inspirational for a younger generation today. However, I find restagings a form of nostalgia, a variety of retro or a reflexive celebration of a failed utopia.

RG: It seems that interest in the 70s is less about historicizing a particular moment and more about rediscovering radical notions of dissent. We recently did a series at NYU, *Not for Sale*, where all the works were *not for sale.* Chrissie Iles and Rob Storr were the curators. Joan Jonas said to me, "RoseLee, I want you to know *I am for sale!*" Part of the discussion centered on why performance is suddenly now so interesting for the museum. I believe one reason is that in looking at the 70s, the museum has to figure out how they're going to incorporate Jonas's or Acconci's performances into its institutional context.

CT: Do you find many young artists today whose works are similar to those of the 70s?

RG: In terms of provocation? Yes: Walid Raad, Tino Sehgal and, of course, Maurizio Cattelan, who can brilliantly manipulate the market and profit from it.

CT: It's fascinating to see the disciplines or backgrounds from which some artists emerge. Tino Sehgal was a dancer who studied economics; his works with fleeting words and movements are scripted by

/ RoseLee Goldberg

him, performed by others and saved only in the memory of the participant/players. With no photographs or videos for sale, it's possible to purchase a work—but only in the presence of a notary with whom a collector must negotiate on how and where the piece is to be executed.

RG: He's coming full circle from conceptualism in the 70s to today's lively art market, from which he's determined to make a living.

One of the first ideas about doing PERFORMA came to me after seeing Shirin Neshat in Venice in 1999; she did a spectacular video piece sited in a cavernous space, which gave rise to my asking myself, *Why doesn't performance look like this today? Why are we still doing 70s-type performances?* We are so sophisticated, installing large-scale video and awesome film works in exotic environments, and yet I didn't see this spectacular quality in performance art. I felt that Shirin's *Turbulence* had the qualities that performance could have: emotion, storytelling, scenery and great music. I returned to New York and asked her if she would consider doing an interactive piece in which the characters in the work could walk off the walls into real space. Shirin has a choreographic ability, she moves crowds, she understands sound and she is a storyteller in the simplest terms. Her work deals with male/female, East/West, ethics and morality. Shirin agreed to do a work. Then we did a workshop at the Kitchen and went to MASS MoCA where her *The Logic of the Birds* was produced.

CT: Joan Jonas's recent piece at Dia was similar in its multimedia format, a live performance plus video/film, but it's much more abstract. Performance artists from different cultures and backgrounds work in different ways: the films of German-born Bjørn Melhus are his self-staged performances; Pia Lindman, from Finland, does live street events; and the Canadian artist Janet Cardiff programs *walks* in which the audience is complicit in her narrative. Do you incorporate all genres and cultures of performance in your program?

RG: I personally can't separate the material from the context of the time and place. I'm now working with artists who haven't made live performances before; Isaac Julien, for example, was invited to observe while I was working with Shirin, and he consented to do a live piece, *The Ice Palace*. It will be included in the Next Wave Festival at BAM in 2007 as a chapter of PERFORMA 07.

CT: How and where do you acquire the funding for the productions?

RG: I'm on the phone day in and day out. For Shirin, I called the Peter Norton Foundation and talked my head off about how exciting it was, and they agreed to help. The Ford Foundation came through quite extensively, and frankly, I called everyone I knew. I'd never done this. I was writing books, teaching and curating, running the Kitchen's programming, but never had I raised this kind of money. My new mantra is *Fund it!*

CT: Marina Abramovic once said, "By the 21st century there will be no art objects at all, just a direct transference of energy from artist to audience like the samurai in old Japan looking at each other and transmitting energy." Yet today, as the marketability of an object has become the main attraction for the collector and the artist; even Marina is complicit in providing beautifully photographed works for sale.

In 2005, for PERFORMA, Marina's *Seven Easy Pieces* at the Guggenheim was a restaging of various 70s works, which were not intended for future versions or objectification. This is evident from the lack of careful visual documentation of these events. Instead, there are word-of-mouth descriptions, unretouched snapshots, Super-8 films or unstable Polaroids.

In comparison, Mozart's handwritten compositions or Balanchine's dance notations prove that they were intended for future interpretation. It seems to me that without evidence to the contrary, Marina's *Seven Easy Pieces* transgresses the artists' original meaning. The works are presented out of context, and in a sense they can be seen as pandering to market-driven commodification.

RG: I think she's wearing several hats; I understood what she was doing in terms of history, and about the importance of this history. The kind of things you were describing, ephemerality and the lack of objects, were the ethos of the 70s. Everyone thought that way, and there was no art market. These things change—and Marina herself came through this evolution in several ways: one was to watch the new generation of extremely talented young people (artists, students) making a lot of money with their own art. Artists like Baldessari or Acconci, for example, who didn't make objects and weren't making the money their students were, went back and made drawings of their previous works for which there was no documentation, and could now be sold. Marina is in a conversation regarding re-enactment, conservation and the nature of documentation that is focusing on performance history. By restaging her own performances, beginning in the late 80s with *Biography*, she theatricalized her entire oeuvre. And she kept adding new works until she asked Michel Laub to take over as the director of the production at the Festival d'Avignon.

There's lots of interest in reconstruction and in relics of past performances. Tania Bruguera actually began her career re-enacting works by Ana Mendieta as a way of bringing Mendieta back to Cuba. Marina's doing that piece at the Guggenheim was important. It's a history, and we must think of ways of showing this in a museum context. For Marina, becoming a museum artist was an insistence on the *immaterial* being as pertinent as an Yves Klein painting. Furthermore, rather than denying a piece's original intent, a restaging positions people to rethink a work done at another time.

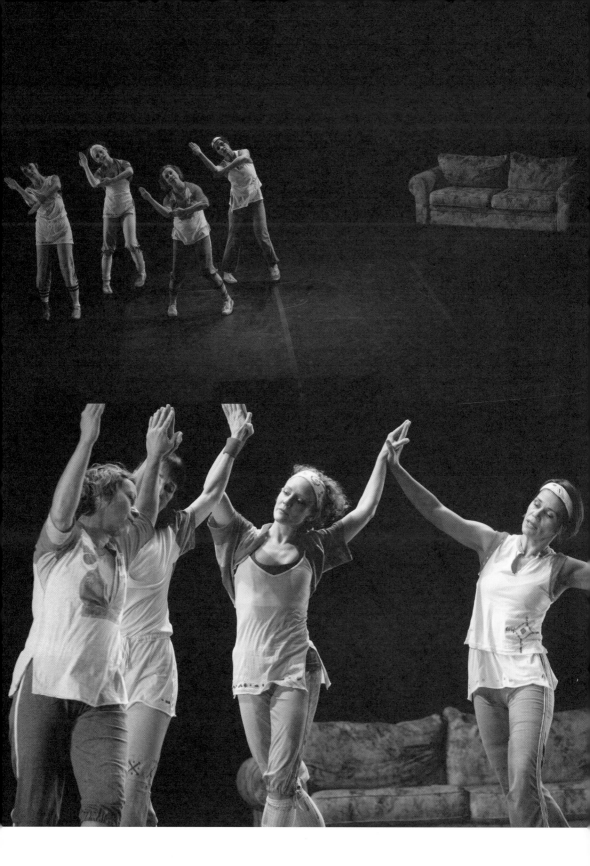

CT: What about the importance of context?

RG: History is history... I wasn't there for the original events, and thus it is that reality one must reckon with. I think it is OK to reinstate (restage) things, and in this way they become something different. Finally, it's a discussion.

> CT: Yvonne Rainer said of her re-creation of Balanchine's *Agon*, "Maybe re-creation is a destruction of the revered icon. Is this an autopsy? It seems to always engage the audience in multiple revelations both familiar and unfamiliar."

RG: Marina is discovering the radicalism of works in their own time. Her re-creations are establishing a value and are thus coming into another (today's) history. As for Yvonne, we've commissioned a work from her, *Rite of Spring*. I always tell my students that *history is now*. However, history in its time was always radical. Obviously, we could do an archaeology of the art world in dioramas with reconstructions and descriptions of historic moments that contain other values from other times. In a natural-history museum, the curator takes a little teacup and constructs from that an entire civilization... but it is only her interpretation. Historians translate history in different ways, through different personae or political lenses. It's the job of the next generation of curators to see how performance works will be presented.

> CT: I'm curious to understand the reach of young performers. I read a conversation between Sharon Hayes and Yvonne Rainer where Yvonne says, "Re-speaking or redoing sometimes brings death to the original. You kill it and cannot kill it at the same time. The death of the original combined with the desire not to kill it creates an interesting tension."

RG: What the artist does is to articulate the present. Most people don't really live in the present, they are not absorbed with the present, but young artists are! The fact that the 70s are very much a part of current discussion tells us a lot about *now*. It is also a discussion that I continue to have with my co-curators, as this is not a phenomenon of performance only, but truly of our time... The aim is not to historicize but rather to appropriate or pick up in a critical sense—making something entirely new out of it.

> CT: Interesting point. To serve as a gauge to where I am in relation to my own past, I often reread the same book after intervals of several years.

RG: T. S. Eliot said, "The past should be altered by the present as much as the present is directed by the past."

/ RoseLee Goldberg

(facing page top, bottom)
Yvonne Rainer, *RoS Indexical*, 2007.
Courtesy Performa. Photo: Paula Court.

CT: As the artistic director of Documenta XI, you've chosen to focus mainly on the themes of global transformation and post-colonialism.

OE: These topics present a model for thinking about the fragmentary aspects of our modern world. They allow us to look at contemporary art in a more complex way, rather than reducing it to the Western museum model; not to negate it, but to confront it with a new set of imperatives.

CT: In defining the problem of language, Noam Chomsky used syntax alone as a point of investigation, enabling him to propose a formal theory of language. For Documenta XI, since the documentary mode was so predominant, should we consider this a similar method of investigation, positing a route into our current state of upheaval?

OE: I do think the documentary provides greater access to dealing with the many questions thrown by the unruly history of multiple traditions jostling for space beyond the ideology of neoliberalism and capitalism.

The perception of the role of the documentary here is not necessarily incorrect, but the interpretation is wrong in that the very language of the fine arts today casts the documentary as ideologically fraudulent. Perhaps it is interesting to look at the history of Documenta, which could be best described in terms of three different periods. The first was strictly engaged in the history of the avant-garde and Germany's reintegration after WWII. The second part involved the idea of the neo-avant-garde model instituted by Harald Szeemann in 1972 and which came to a close in 1997 with Catherine David's Documenta X. For me, Documenta XI presupposes a new moment having to do with the historical necessity that has brought to our attention a greater number of artists and intellectuals working outside the singularized model of contemporary institutions.

CT: Edward Said wrote that "culture works very effectively to make invisible and even 'impossible' the actual affiliations that exist between the world of ideas and scholarship ... The cult of expertise and professionalism ... has so restricted our scope of vision that a positive (as opposed to an implicit or passive) doctrine of noninterference among fields has set in." In this respect, Documenta XI seems to attempt to undermine that narrowness.

OE: I would hope that Documenta XI and my other projects have opened up new spaces for other articulations.

/ Okwui Enwezor

(preceding pages [detail] and above)
Allan Sekula, *Conclusion of Search for the Disabled and Drifting Sailboat "Happy Ending,"* 1993–2000.
Courtesy Christopher Grimes Gallery, Los Angeles, and the artist.

CT: Maybe in order to restore the energy of lived historical memory and subjectivity, reality is important, not mysticism, metaphor or alchemy.

OE: The reception of the show has varied in different places. One of the measures of Documenta XI is its density. Therefore, I believe it's impossible for it to be encapsulated under one doctrine or critique. The documentary mode has to do with the perception of an attitude: that of a middle-class public toward what the documentary puts before it as representing an excess of reality—confronting us with the unsavory elements of the abject in contemporary global culture.

I view Documenta XI as a mode of analysis working within a temporal and spatial regime, allowing us to see the work of art and ideas in the present without making an abstraction out of them or creating an undue ideological distortion. It is interesting how people engage in the procedures through which the documentary form moves into the contemporary art space.

CT: One critic said, "While rightly skeptical of the self-referential autonomy of much recent art, Documenta XI is a paradoxically and often a simplistic and curiously prescriptive affair." Another said, "The ideology of political correctness has led to a display of works that 'show artists as poor sociologists and anthropologists.'"

OE: I completely disagree with these people. There's a typical knee-jerk reactionary stance toward the kind of works we've assembled. It is a way of cutting off the debate and leaves very little room for other manners of thinking about visual practice, culture and audiences.

For example, the exhibition being critiqued is only one of five different plat-forms we created. If these people had followed our projects more closely, they would have understood the setup better.

CT: Maybe, as they were positioned outside the normal viewing frame, they were ignored.

OE: I find it disconcerting that the one mode of critique that has been asso-ciated with Documenta XI is the documentary; there are many more layers in the exhibition, and the whole project spanned 18 months and included hundreds of audiences.

CT: It should be no surprise that the curator of a Documenta is faced with such demanding criticism.

OE: It should be expected, and I accept that the exhibition can raise a healthy debate. I continue to insist on the validity of some of the critiques not because I agree with all of them but because they need to be posed in order to cut through a number of layers in the project.

CT: Obviously, a curator's work is not done after the selection of art-ists or themes. The exhibition must also be choreographed; this was especially evident in the Binding-Brauerei venue. Here the works of Manders, Orozco, Evans and Huyghe flowed into and out of your theme with compulsive madness, curiosity or humor. The works of Kutlug, Ataman and Joan Jonas dealt imaginatively with unconscious

fears and desires, while others that were not particularly political could have been construed as such given the thrust of the show.

OE: It's interesting to look at the exhibition as a medium that is part of a continuing cultural practice. What comes out of that understanding is a larger awareness of how you tell a story, because exhibitions are narrative by nature—one thing after another: sentences, paragraphs, line breaks, punctuation, exclamation marks, etc.

We were aware of the integrity of the artists' work as a foremost concern. Consequently, we always kept in mind how works unfolded and flowed into each other and how the use of the space allowed the viewer's subjectivity to emerge beyond that of the curator and artwork.

An exhibition for me is as much a textual as a visual device; how you scan left to right, right to left. If I were to pick up an Arab newspaper I know that I'd be reading right to left, and a Chinese text is vertical (which, incidentally, is how traditional Chinese landscape painting orders space), and thus you try to understand the different ways your audience can enter the work through the scheme of the exhibition. With Hanne Darboven, for example, we tried to set up the installation not simply as a linear narrative reading, but to re-conceive its narrative density by putting it into a spiral. Following the curve of the wall in the rotunda of Museum Fridericianum and moving up and down, there was, at least for me, a perceptible musicality to these enigmatic and obdurate signs on sheets of paper.

CT: The platforms were published on the Internet, which gave me the opportunity to hear a formal description of Allan Sekula's photographs. Why were so many of them displayed?

OE: Throughout the exhibition, we chose not to present fragments from an artist's work, but to present the complexity of the initial idea. You wouldn't show only three minutes of an hour-long film, so why limit a photographic project such as Sekula's, which contains 105 panels? We wanted to respect the artists and give them the proper space in which their ideas could be most fully realized.

CT: Historically speaking, painting once served the market economy of the ruling class. Its maturation and dominance as an art form paralleled the rise of capitalism from its birth in a declining feudal economy. Painting was a commodity that reflected a cultural and social shift, one that was reduced to its economic value and interchange. Why were paintings in short supply in Documenta?

OE: The most immediate answer is that in today's art world, there is no dominant medium. For centuries, painting enjoyed a preeminence unequaled by any other medium. I don't know why this hasn't continued as it did throughout the 20th century. Might it be that artists have shifted their emphasis? Great painting is still vital, but it has to contend for space with other fields and practices—which are not necessarily bound to a single medium.

/ Okwui Enwezor

Kutlug Ataman, *The Four Seasons of Veronica Read*, 2002. Courtesy the artist and Lehmann Maupin Gallery, New York.

I also don't think the lack of painting in the show was an intentional omission or a political statement. The exhibition presented its intentions very clearly. In that sense, I would agree with a lot of the critiques; it was really more about non-ambiguity with a sense of its own clarity, rather than trying to clarify its objectives. Perhaps what made a lot of the work in Documenta XI seem political was the intensity and directness of the experience of the works.

CT: How did you work with your curatorial team?

OE: I was not interested in an advisory role for my colleagues. I wanted a much more involved process—a think tank where everyone had equal opportunity to speak, to introduce ideas, to open new avenues. That didn't mean we weren't working with a set of propositions, which I initially sent to all of them. While the propositions underlying the platforms were previously developed, the content that went into all of the platforms was collaborative.

CT: The anxieties infusing cultures today are not all politically induced. Some stem from the complexities of the information age, biotechnology, ecology, or gender.

OE: We tried to script it to have many different concerns. The platforms were mutually determining and autonomous, specifying a number of approaches for thinking more fully about the context of the production of knowledge in the present global dispensation. The platforms also provided the opportunity for many concerns to be voiced within the common ground of the community of ideas, rather than to pretend that they are not present in the debates of contemporary visual culture and art.

CT: Let me go back a bit. Just ten days after September 11, 2001, at a panel discussion during the Istanbul Biennial 7, you said of the World Trade Center bombing, "This natural disaster epitomizes the new demands and needs for reevaluation and study of the unrealizable aspects of democracy in newly liberated and forming countries." What are some of your thoughts about this now?

OE: September 11 was a response outside of the claims of advanced capitalist economies and zones of democracy. The demands coming out of those places have been around for some time, but their analysis hadn't been attempted inside the metropolitan zones where large symbolic power is vested. This is why I think it was such a shock to people; it wasn't just the violence that typically shocks people, but it was also the sensational means through which the violence was actualized and communicated. If we investigate these pre-9/11 issues, such as the evolving concepts of modern societies, we can see that they already had been addressed by artists and intellectuals outside the framework of advanced capitalist economies.

CT: Probably the event coalesced an underlying universal consciousness?

OE: True, it's been there for quite some time, at least from the very moment

/ Okwui Enwezor

Thomas Hirschhorn, *Spinoza Monument*, 1999, Midnight Walkers City Sleepers, W 139, Amsterdam. Courtesy Gladstone Gallery.

the global financial system emerged. Edward Said and other thinkers have tried to understand these basic schisms that produce ambivalence, misunderstandings and different levels of dissociation and identification among people living on the rim of the larger global economy.

It would be difficult to say whether the context of artistic production has changed. I haven't seen this being addressed in any serious manner in contemporary art today. Perhaps we need a greater distance to allow things to settle down.

CT: A critic from the *New Republic* [James Wood] has dubbed the overblown, manic, anxiety-ridden, emotionally confused, intellectually scattershot attitude exemplified by Zadie Smith's *White Teeth* "hysterical realism." Don't you think that this is an apt label for many artworks today—by Thomas Hirschhorn, John Bock, or even Eija-Liisa Ahtila?

OE: This analogy of hysterical realism escapes me in the works you mention. Hal Foster has a notion for the same condition in contemporary art, which he calls "traumatic realism."

It worked for a long time and it does have something to say about how certain highly symbolic spaces of cinema function. The work must also be looked at in the context of the manic psychic concerns of the Nordic condition—as some have called it—which has been a kind of quasi-clinical, analytic trope of much of Ahtila's work. She is the prime woman for the idea of expanded cinema, as Stan Douglas is with obsolete forms of cinema, or Isaac Julien with narrative decomposition.

In the end, it's interesting, however, that you're trying to make a conjunction between literature and contemporary art; it needs to happen more. I certainly see Zadie Smith as a contemporary of Steve McQueen and Gillian Wearing. Elizabeth Peyton's attraction to feckless celebrity indicates how inured we are to contemporary mass culture at large. As such, this generation of artists and writers are fully engaged with the social world. It would then presuppose that artists are mining bodies of information and knowledge wider than the narcissistic gravitational pull of much contemporary art.

Some can choose to call this "social documentary." I really don't care. But it is there. The question is: on what terms do we receive the news of this condition of realism, be it hysterical or traumatic?

CT: Not to overlook the narcissistic aspect or dismiss the formal obligations imbued in art making, but there is an anxiety marking today's culture fueled by natural or unnatural aspects of a changing world: biological and digital technology, post-colonialism or simply the speed of time, wars and capitalism.

OE: Maybe if the artist uses a patchwork of different sensibilities then he'd be able to talk about symptoms of the present anxiety with well-honed—albeit overly descriptive—self-awareness. We should be able to look at this and ask, what does contemporary art mean today and what are artists trying to say beyond the formal relationships they have with the market and art institutions? A theorist and historian like Rosalind Krauss has come up with a compelling denomination of "post-mediumness" for the sheer variety of strategies that often inhabit one single work to the point where the collision of strategies ruins the condition of specific media. Frederic Jameson has come up with another term he calls "post-contemporary." This term also seems inadequate as a description; rather, it is more of a diagnosis. I am much more attracted to the latter, because labels are about fashion and the market.

CT: Tell me what it meant to you to curate the show *The Short Century: Independence and Liberation Movements in Africa, 1945–1994* at P.S.1.

OE: Rarely does one create an exhibition that has the kind of deep emotional and intellectual impact on one's larger framework as I had with *The Short Century*. It was one of the most satisfying shows I have ever made, not because I was pleased with all its facets, but because while preparing it, it constantly gave me pause and excited many buried sensations of being African. I recently reread Chinua Achebe's book *Home in Exile* and it captured so wonderfully how I felt. In the book, Achebe humorously tells the story of an African proverb, the origin of which an American professor of comparative literature had asked him to explain. The proverb goes something like this: "Until the lions invent their own historian, the story of the hunt will always be that of the hunter." For me, this is what *The Short Century* was about. Until you have the competence to tell certain stories, you'll always be defined by the hunter!

CT: *The Short Century*, then, was your effort to tell the story of the hunted rather than one from the hunter's—or colonialist's—vocabulary.

OE: Actually, they're both deeply entangled. This is what *The Short Century* wanted to say, as well as the modernities and histories of the post-colonial world. I didn't want the exhibition to function as a binary opposition or perspective, but to focus on the larger historical backdrop against which artists and intellectuals could begin to explore their task in the formation of modern culture.

CT: This show, then, is also a way for the hunted to see themselves on their own terms?

OE: Absolutely. It develops a new kind of dialogue within our very fraught heritage, struggling for definition.

CT: Harald Szeemann said that after doing a mega-show like Documenta, given the mammoth nature of the task and the critical aftermath, one must reinvent oneself. So what will you do now?

OE: I suppose I should take his reflection very much to heart. Curating a Documenta or any large show is a highly involving thing, like running a marathon. The nature of curating a Documenta takes a long time and places demands on one's ability to remain sharp, enthusiastic, open and questioning.

Right now, I'm in a state that's strange; it's an ambivalence one has toward an exhibition like Documenta, of which one says so much that speech is exhausted. So now, it's quite important to sit back and catch one's breath. (I also wish someone was paying for this sabbatical.) I don't believe I need reinvention, as there's nothing to reinvent. I need a restful time—emotionally, intellectually and physically.

When the lights are turned off, there's always the "What's next?" Surely not to get trapped in larger and larger productions! I'm currently writing a book, hoping it will sharpen my thinking about various questions, reviewing the propositions in Documenta and beyond.

More than reinventing oneself, the issue is, what is the space of culture today and how can a curator have an important voice in its shaping?

/ Okwui Enwezor

John Bock, *ArtemisiaSogJod Meechwimper lummerig*, 2000, installation view, Klosterfelde, Berlin. Courtesy Klosterfelde, Berlin. Photo: Jens Ziehe.

/ **Charles Esche**
Interview 2005

CT: Your curatorial practice is closely related to your life as an activist and innovative risk taker. You were born in England in 1962, brought up in Manchester and London, and joined the Labor Party. At 21, you became involved in the miners' plight and, a few years later, you entered the Medieval Studies program at the University of Manchester. What attracted you to that particular university?

CE: The nature of Manchester's interdisciplinary program was an imaginative opening for me, a crossing of borders. While there, I went to galleries and saw some things that were intimate, personal, subjective and far more open to political interrogation.

CT: In what way?

CE: Well, it wasn't necessarily political art but art that could be seen in a propositional sense, about an *otherwise* where things tie into each other.

CT: Many curators and artists have come to their profession from other disciplines. Do you see a difference or commonality in their approach?

CE: Frankly, I think it's important to enter curatorial practice from another field. To be trained solely in art history, looking for lineages and provenances, hinders you from thinking about art in a broader frame—a connective tissue that unites positions and questions in a way that a disciplinary structure does not.

CT: The word *curator* means "overseer, guardian, agent." In Latin law, the curator was appointed guardian of a person legally unfit to conduct him- or herself, such as a minor or a lunatic. However, the curator in the Middle Ages is known specifically as somebody in a clerical position, a priest for whom the exhibition would be an ecclesiastical display and who would be crucial to the organization of religious spaces and beyond.[1] Today, in the exhibition, the curator takes into account both the zeitgeist and repressed history—a history associated with individual motivations, with the transcultural and the mythic. With religion, change is complicated, but in art change can be liberating.[2]

1. Stephen Bann, "Exhibitions Reflecting the Art and Spirit of the Age," in *Stopping the Process: Contemporary Views on Art and Exhibitions*, ed. Mika Hannula (Helsinki, Finland: Nordic Institute for Contemporary Art, 1998), 89.
2. Ibid., 86.

This year [2005], for the first time, women are curating the Venice Bienniale. What are your impressions of this show?

CE: I'm not sure that this model in Venice is a true description of art and the public's condition. I think the antidote for the problems around the Venice Biennale is to find a radicality elsewhere and not a radicality in returning to the past, which I think is what this Biennale is about. This is a step backward—like something pre-1999 and definitely pre-2001.

/ Charles Esche

(previous pages)
Daniel Guzman, *New York Groove*, 2004.
Courtesy the artist, kurimanzutto, Mexico City and Harris Lieberman, New York.

CT: As Rosa Martinez and María de Corral were the first females to curate the Venice Biennale, perhaps they considered their appointment the most radical element.

CE: Both Rosa and María are extremely established and important figures, yet the glass ceiling and limitations for women in the art world are apparent. In the Dutch art system, except for Maria Hlavajova, the curator and artistic director of BAK in Utrecht Netherlands, only men run museums, and I'm quite ashamed of that. Yet, given their situation and respectability, they could have felt empowered to take risks.

CT: It's curious; Rosa Martinez is an innovator who chose to curate a show that included many women artists, but that alone did not move the process forward, which seems essential today. In contrast, Francesco Bonami in his 50th Venice Bienniale of 2003 chose to share the job with other curators who could design their own shows at the Arsenale. With this notion of community, Bonami attempted to overthrow the power and personality of the single curator, "a reaction to Harald Szeemann's persona," he said.

However, the result was not so much about the power of personality but one that through chaos moved the exhibition into other kinds of conversations. Hans Ulrich Obrist curating *Utopia Station* and Hou Hanru with *Zone of Urgency* each signaled the need to rethink the Venice Biennale.

/ Charles Esche

Zone of Urgency, Venice Biennial, 2003, installation view. Courtesy Hou Hanru.

CE: Yes. That's the problem, and maybe it says that Venice cannot be the place where this can be done.

Indeed, Hanru's well-orchestrated show was made up of strong artworks woven into an architectural and thematic structure. On the other hand, Obrist's *Utopia Station* contained many important artists, but as a project it was dressed up in a Che Guevara T-shirt, shrinking and consuming its own radical possibility. It mimicked a capitalist consumer situation with the curator as CEO and the artists as the products, reducing the possibility of the artist.

There's a huge amount of naïveté in the use of the word *utopia*. When you say "*Utopia Station*," you have to be accountable for that term and for the disasters that were carried out in the name of utopia throughout the 20th century. From Constructivism through Rodchenko to modernism into architecture, the political relationship of utopia to art has been complicated.

Socialist realism, for example is a utopian aesthetic: a movement relating to political concerns. A utopia is the political point out of which an aesthetic grows and on which aesthetics is completely dependent. However, aesthetics is not utopia—in these situations, it is a means to get to a political end, it is a doctrine about control systems!

Using the term the way Obrist did, without a sophisticated analysis, repeats exactly the same model in which the artist is at the service of the curator, the ultimate utopian—like Stalin, orchestrating everything.

CT: An interesting analysis; however, many curators use a theme to introduce an idea and to select the art for their show. Is Obrist's show a micro-illustration of the political situation that you're talking about?

CE: I think that phrase, *Utopia Station*, is a nice, catchy term and a good marketing device—but it is also where the danger lies. If you reduce art to these marketing terms, to these superficial, hip-sounding phrases, then you destroy its potential to transform the imagination. It is, finally, destructive.

CT: Well, all the utopias we know, starting with Plato's *Republic*, have been failures in practice. There are times, though, where the artist may imagine a utopia, making works that are non-conformative and oppositional. Earthworks and Fluxus, for example, were political, arising out of a new way to interact with society—a refutation of the commodity system; the work was not about acquisition. Could we call this utopian?

CE: This was not imagining a utopia: it was a doing of practical things with a limited, intimate and specific set of circumstances. Yes, they were thinking of the world in ways other than what it was, but they were working to change the world from the specifics of certain conditions in the New York market.

The Salt Lake *Spiral Jetty*, for instance, was about attempting to make a

difference under the microscope of that place—at that time, with that group of people. That was about the material of living and working together and trying to find a better way.

I believe that the interesting task of an exhibition is to move away from the reflexive form of art toward something more unstable and propositional. The imagination is key: how to generate a collective form of re-imagining the world. We need what Michel Houellebecq calls a *metaphysical mutation*. (Metaphysical mutations occur every once in a while when a new world order rises to the challenge and replaces social and civilization-al rules.)

Houellebecq's book *Les Particules élémentaires*, is not so much about plot, it's about philosophy; characterization serves only to bring forth archetypes of a society that seemingly exists purely for the purpose of promoting individuality, but actually suppresses it when it is considered a hindrance to social rules. By terminating this artificial existentialist society, he creates a vision of utopia. Everything is atomized. His ideal world is where everyone is an individual but part of a collective identity. There is no conflict when there is no difference. Atomized existence. The novel is an update of Nietzsche's discourses on the superman. As a book it is layered and rewards reflection with more points to ponder.

CT: Isn't re-imagining the world a fundamental task of the artist?
CE: It's political at a very intimate and profound level, one at which cause and effect could never be traced. I don't see art in terms of an instrumental political possibility—that would be socialist realism or propaganda.
It was Spinoza who said that the imagination is holding something present in your mind that you know does not exist. Art is a way for human beings—artists, viewers, critics—to imagine the world other than it is. Art emphasizes a knowing self-deception and says if you're going to go along with this, it will have an effect.

CT: I thought you were referring to the mechanism of the artist's

/ Charles Esche

Johanna Billing, *Magical World*, 2005. Courtesy the artist and Kavi Gupta Gallery, Chicago.

mind, and as such, in order for the artist to create, he/she often must suppress the observing ego.

CE: Yes, but I'm a viewer, never an artist, and never could be an artist. My position is always looking at the work and seeing it first in a very intimate, personal way. Then, if I believe in it, I ask, how can I share it? In order to make that possible I must have an extremely close relationship to the artist.

CT: Okwui Enwezor's Documenta X was an exhibition where the documentary mode governed the narrative and was dominantly political. Do you think this denies what is implicit in art—the imagination?

CE: The question is, where is the political moment in art? I don't think it's in the documentary, not in the finger-wagging moments—saying, "Look how much has gone wrong, and look what you've done." Feeling guilty is not the political moment of art. Rather it is connected to imagining things other than they are. For that, you need an erotic impulse and ambiguity—something that is missing in the documentary moment. It must be intimate and it must be a metaphysical transformation.

CT: There were many marvelous works in Enwezor's show, many points of entry—at the Brewery, for example, some artworks played on the same themes as the documentaries but were not considered in the critique. Did you feel they were any less political?

CE: That's a reasonable question, but that project defined the political through the idea of the documentary—and I would reply that is not where the political moment lies. The political moment in art lies in that sensuous and ambiguous feeling and the ensuing instability. This is frightening, but it is where *possibility* emerges. The job of art is to create ambiguity so the viewer can make that transformation.

CT: There are periods in history—especially in developing cultures—

/ Charles Esche

Smadar Dreyfus, *Lifeguards*, 2006, still. Courtesy the artist.

where *modernity* is a new thing, and people are obsessed with the *new* because there is a necessity for it. But I think this happens when society reaches a stage where innovation and tradition interweave. You are co-curating, with Vasif Kortun, the 9th Istanbul Biennial [2005]. Can you tell me about the political situation in Turkey and if that condition is relevant to your exhibition?

CE: We all live under globalized conditions, and in politics it isn't much different. Now that the Justice and Freedom Party is in power with Recep Tayyip Erdogan as Prime Minister, it's the first time in the history of the republic that there is a party related to a religious sentiment instead of a secular one. It's interestingly trying to construct some Turkish version of the world, something that is not just the adoption of another model, as in many other socialist states, but instead trying to modify it according to local traditions, including religious traditions. It's a challenge that's not unreasonable for us to take up.

CT: What is the country's economic structure?

CE: The money is in a few families' hands, and this is a big issue.

CT: Is this why many Turks are leaving the country to find work elsewhere?

CE: Or they're moving to Istanbul. It's grown from 500,000 to 15 million and a lot of the movement has been internal, from Anatolia to Istanbul.

CT: About your curatorial endeavor for the Istanbul Biennial, you and Vasif, your co-curator, chose to avoid the potential dangers of

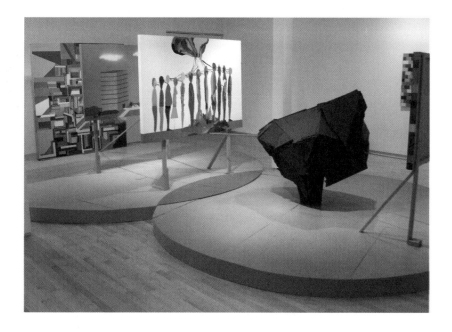

/ **Charles Esche**

Chris Johanson, *Contemporary Landscapes*, 2006. Installation view. Courtesy the artist and Kavi Gupta Gallery, Chicago.

geographic essentialism or limited parochialism by diversifying your conception of its site: choosing places where one would find old industrial warehouses and crumbling apartment blocks instead of the antique and splendid Sultanahmet district.

CE: Our proposal was to create a platform in which the artist could work and include the city of Istanbul. We chose not to use the antique sites, rejecting dramatic or historical locations in favor of showing art projects in the city's more modest living and working environments. The situation we constructed created a certain autonomy for the artist and the viewer to travel about the city. We would not create an umbrella that says "this exhibition is about" or "our exhibition comes from" the conditions that make up Istanbul. One aspect was to invite a group of artists from all parts of the world to *bring news from abroad,* so as not to essentialize Istanbul, and to temper arrogance by realizing through the work of artists what possibilities may lie elsewhere.

For example, the Palestinian Khalil Rabah re-sited the Palestinian Museum of Natural History and Humankind, established in 1905, at the Deniz Apartments. The work was titled *Palestine before Palestine*; he gathered sections of the museum archives, its permanent collection of fossils, bones, alien matter and other artifacts; there were publications, a study area, a shop and a café. Another artist, Chris Johanson, created an installation directly responding to his surroundings on the West Coast of the US, which represented another kind of coastal culture, different but frequently apparent here through the media and film.

CT: My favorite installation was by Michael Blum, *A Tribute to Safiye Behar*, a multimedia piece alleging that Behar, a Jewish feminist Marxist living in Istanbul in the 1900s, was a paramour of Kemal Ataturk. The work contained "original" diaries, photos, furniture and documents from an imagined collection, and suggested analogies with similar house museums such as Trotsky's in Mexico City, Freud's in Vienna and Marx's in Trier. Ultimately, the historical/hysterical construction gave the illusion that Behar's house was a real museum. The uncertainty between modes of presentation allows the work to take flight in our imagination: it was *erotic* in this way.

CE: There was also the *hospitality zone*, which included a variety of international projects in which people could do their own thing. We constructed conditions out of which this art could emerge, not as an umbrella or theme, but through residencies lasting one to six months that addressed the inner-city reality, a workshop of art schools, and two artist groups, one from Kurdistan, one from Istanbul. Often these projects were local, small-scale,

and included cultural activities, cultural activism and artists' programs
with kids that were supported by a foundation or individual donors. Our
purpose was to encourage a number of activities to go on in Istanbul, a
city of 15 million that doesn't often communicate with itself.

Frankly, it's a challenge to do this Biennial. I'm not a fan of the government
or of what governments can do; I'm a fan of the culture and the contempo-
rary art scene. It is a culture where things are possible—the fear that the
future will only get worse isn't as prevalent, and there is an idea that things
are worth trying.

/ Charles Esche

Michael Blum, *A Tribute to Safiye
Behar*, 2005. Courtesy the artist.

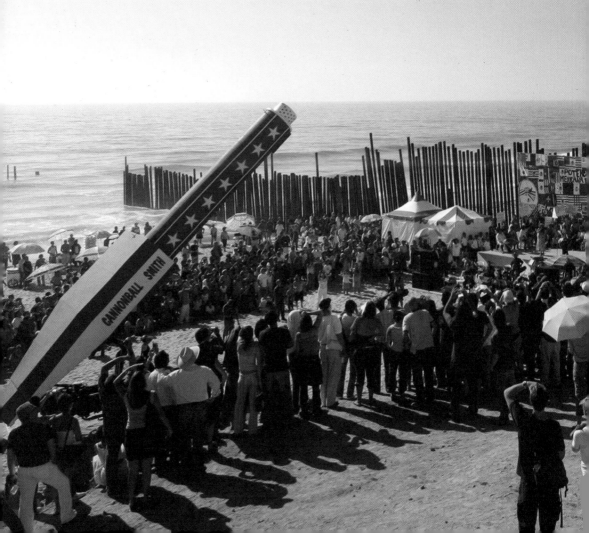

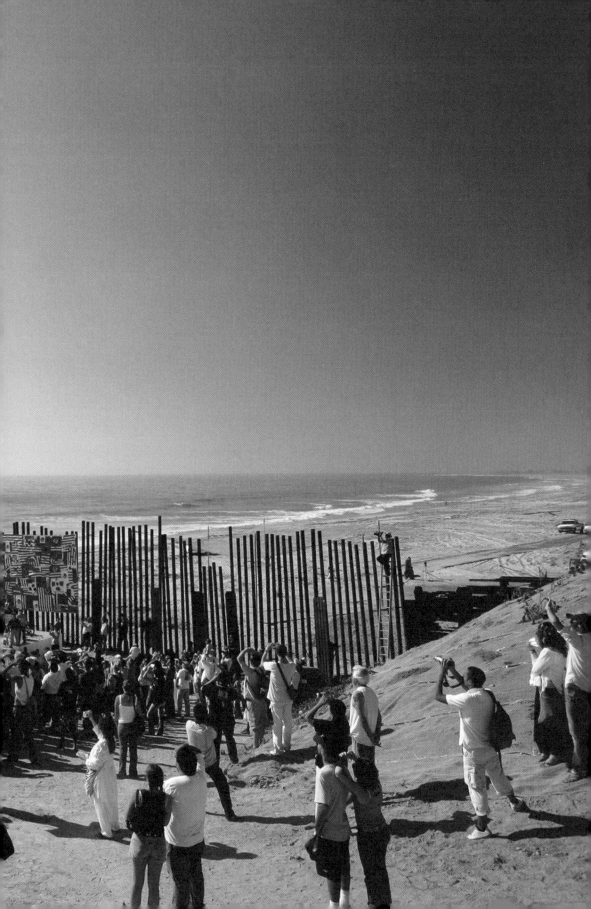

CT: Large international survey exhibitions like the first Torino Triennial, which you are co-curating with Francesco Bonami, serve as a way for artists and curators to explore the frontiers between object and process, research and culture, interrogation and audience, technology and politics. Don't they also function as a transnational marketplace for elite consumers preparing for the onslaught of corporate imperialism?

CCB: I don't think, nor speak, in terms of "corporate imperialism" and I don't believe curatorial or artistic practice is immediately a political act. I'm interested in how knowledge is constructed—to observe art on the micro level of a single artwork and see how it's negotiated in the world. At the same time, everything we do, including art, is political, one way or another.
The exhibition/biennial, as we know it, emerged from a democratic impulse. Before the French Revolution, there were only private exhibitions, which then developed into the public arena, the museum. Today, however, the public exhibition is on a decline due to the increasing cultural legitimization of the art fair. This can be traced back to the 1980s and to the increased presence of curated projects within art fairs.
Recently, I believe that large international exhibitions have at times become cynical, postmodern visions embracing a pop Andy Warhol attitude.

CT: Why do you say that?

CCB: Because some projects are based on a naïve idea that if you get a larger audience you can achieve more of a cultural impact.

CT: With regard to patronage and collectors, some might think that there's a conflict between your two roles: one a curator for a major museum, the Castello di Rivoli, and the other a co-curator of the Turin Triennial.

CCB: I don't think there is a conflict—I don't deal with patronage and collectors in my museum work. There is no conflict. All I am saying is that I think that in international exhibitions, more depth is needed—these exhibitions are usually researched and prepared too quickly for that depth to be achieved. I too have put together the Triennale too quickly, for example, but my museum experience of organizing large exhibitions with a certain thoroughness has made it a bit easier to avoid the typical pitfalls of the Biennales.
For this show, *The Pantagruel Syndrome*, I use a strong narrative—something I often implement in group shows. Pantagruel is a literary figure created by François Rabelais [c. 1494–1553], a major French Renaissance writer, doctor and humanist. He is regarded as a proto-modernist writer of fantasy, with rude, heroic and humorous giants perpetually traveling in a

/ **Carolyn Christov-Bakargiev**

(previous pages)
Javier Tellez, *One flew over the Void (Bala perdida)*, 2005, still of single channel video installation, project for inSite 05, San Diego /Tijuana. Courtesy the Artist & Galerie Peter Kilchmann, Zurich.

world full of greed, stupidity, violence and grotesque jokes.
The character Pantagruel is of gigantic proportions with a voracious
appetite and incredible power—characterizing the fragility between a
healthy form of desire and a sense of imminent disaster and out-of-
control voracity.

> CT: Yes, this seems an appropriate reflection of our consumerist
> society. Does this poetic device also move our focus away from
> the curator?

CCB: Yes. I'm intentionally moving the attention away from the *auteur*/cura-
tor. At the panel discussion held during the opening, few of the ten invited
curatorial correspondents talked about whether it made sense to discuss
Pantagruel as metaphor. They instead wanted to talk about innovation of
process, venue, and curatorial practice.

> CT: Innovation in the practice is a legitimate concern among curators
> today.

CCB: Well, I do believe the group exhibition is in crisis also because of too
much attention paid to curatorial practice. However, it's interesting to note
that in the mid-19th century, the salon emerged from the model of the
trade fair. For example, at the first Venice Biennial of 1895, the art was
labeled and priced, and the show's success was measured by how many
works sold. So from this point of view, the rise of curatorial practice as a
field has been positive, moving exhibition-making away from the old fair.
With the modernist impulse of the 20th century as well as the autonomy
of the artwork and the rise of the radical curator, the exhibition began to
slowly detach from the marketplace. And so at the end of this history, we
have returned to the beginning, the exhibition as art fair.

> CT: So let's return to the late 19th century, where the biennial begins
> not only as parallel to the trade fair but also as a time when artists
> were breaking away from the salon, progressing on their own.

CCB: But the Impressionist shows also marked the birth of the marketplace
and the galleries.
I believe we're at a point where the system is in crisis. The people who
organize and curate feel they need more depth, and this impulse has
brought a lot of interesting curatorial experimentation in the 1990s.
Hans Ulrich Obrist, for instance, is a curator whose genius and frustration
with the traditional group exhibition compelled him to experiment with its
form throughout the 1990s. He learned from the artist Alighiero Boetti
that to invent new rules of the game would move it to innovative terrain.
I believe in intuition. Thinking about process is overly self-conscious,
and analyzing everything contributed to the failure of postmodernism.
Hans' procedure was both intuitive and systematic, and helped open up
the system.

/ Carolyn Christov-Bakargiev

CT: Yes, but the artworks/artists as the propellants and ingredients of the curatorial process cannot be denied; it is the artist who is the seismograph of change in society.

In a discussion moderated by yourself and co-curator Francesco Bonami that took place during the opening, the ten correspondents were not only panelists but had also been asked to suggest artists for the Triennial and contribute to the show's catalog. What could have been a lively discussion was squelched when you said you disliked the 2005 Istanbul Biennial—that those curators, Charles Esche and Vasif Kortun, were interested "in process and experimentation, not the excellence in the artworks."

CCB: I did not dislike their Istanbul biennale. That is a misunderstanding of what I said. I meant that Charles prioritizes theory, the experimentation of curatorial practice and the political effect of art over the focus on art's solitary and sensual adventure—over art for the artist's sake, let's say (a twist from "art for art's sake," and I think this procedure is ultimately political anyway, but in a different way from how Charles and Vasif may envision the political). The idea of their Istanbul Biennial 9 was to move curatorial practice forward, but not a lot of the art provided the emotion that brings new knowledge to me (it may well have to others). The art I love elicits an emotional and bodily reaction in the viewer. Harald Szeemann understood this, and I share that pleasure in embodiment through art.

CT: Leo Steinberg in *Other Criteria* said, "The general rule is whenever there appears an art that is truly new and original, the people who denounce it first and loudest are the other artists." This is also true of curators or others engaged in any profession who, when faced with the *new*, have the most anxiety.

Personally, I think Charles Esche has an amazing eye. While most of the art was neither pretty nor a commodity, what Charles and Vasif did at the Istanbul Biennial was to override conventional bourgeois thinking and move the Biennial to a less comfortable place, less attractive to the elite traveler but more engaging to Istanbul's populace.

CCB: Charles and Vasif are great systemic analysts of constructive curatorial process and of art/politics relations; I respect their vanguard, activist position and the form of curatorial experimentation, which is not done for the sake of experimentation, but for that of social change. Their show represented an act of resistance, which I totally respect, but I personally don't believe in acts of resistance. I'm a pacifist and a feminist and feel change can be achieved through more invisible and less confrontational means.

CT: But acts of resistance can initiate change.

CCB: Each historical, social, political and technical moment in the history

of mankind has determined different ways of resistance. Hogarth or Goya's form of resistance, is not necessarily right for today. Failure may be more productive than success, withdrawal more interesting than attack. Again, this is my perspective, which comes from my personal experience.

I've worked both outside and inside the institution. In 1993, in Antwerp, where as young emerging curators, Iwona Blazwick and Yves Aupetitallot and I had been invited to curate a show (it really meant "bring in international artists to help launch the city into globalism"), we curated a project called *On taking a normal situation and retranslating it into overlapping and multiple readings of conditions past and present.* However, we did the opposite of what the conservative forces in the city really wanted us to do. They wanted a local, national show and we created a local exhibition indeed, however one which revealed an avant-garde and international history of Belgium. We chose artists from local collections: Lucio Fontana, Niki de Saint Phalle, Lawrence Weiner and others and placed them in the museum. Oddly enough, this extremely local show was therefore on the surface absolutely compliant with the right-wing nationalist politicians who were originally against our mission. In reversing the paradigm we gave them what they did not expect and revealed a culture (their own in the past) that was open, avant-garde and internationalist. This caused a short-circuit in Antwerp.

> CT: I see—you've worked both ways. Was capitalism, consumerism or spectacle an issue then as it is now?

CCB: Again, you use terms I do not. "Capitalism" is a reductive vision of the history of mankind. *The Pantagruel Syndrome* is about the effects of power in general, not just those of the phase of modernity we call "Capitalism." Power is grounded on subjugation and it is manifest in many ways that go beyond economics and into psychoanalysis, for instance, the power of an adult over a child, or over the elderly, or a husband beating his wife, or of humans over other animals, etc. These are not "capitalist" issues only.

> CT: By enlisting parables and fables in her performances, Joan Jonas illustrates these power relationships.

CCB: Yes, and I love Joan's art. I often talk about power and human survival in general terms rather than speaking about capitalism, which describes a subcategory of power relations. Art has a more direct influence on the world than politics often do; Masaccio changed the world because he changed the way we see the world: his brutal figures reversed the social hierarchy and thus the power relations in Florence in his time. In the long run, art has a deeper effect on human beings who are trying to understand the issues of their times than direct political actions do.

> CT: Each new exhibition can be a laboratory, informing strategies that

combine with obligations for new communities of discourse. Some specialists make the distinction between curating within the canon or within the culture.

CCB: I think the need for curatorial experimentation has become canonical, not radical! We are years after those radical experiments of the early 1990s.

CT: It's an interesting dichotomy for today's practice; you talked about what you did in Antwerp in the 90s, curating outside the canon and now that's no longer remarkable to you.

CCB: Yes, canons change, and if the experimental has become the canonical today, it is then the most cliché and obvious thing you can do. I'm not trying to work in the canon of experimentalism now, and this is how *The Pantagruel Syndrome* needs to be understood. As a non-experimental, ultimately boring, endeavor. It does not engage in curatorial experimentation.

For me personally, I believe in making *decoys*, but let me explain. Some of the young curators at the aforementioned panel discussion remarked that the *Pantagruel* exhibition was traditional rather than innovative. They questioned it as *theme*, which did not get us out of the syndrome. For me, however, the show is only a decoy. It offers a spectacle that distracts everyone, so artists and intellectuals can get on with what they do, in the gaps of the spectacle. I don't try to beat the spectacle, I just work in the sidelines of it.

CT: The subject matter is important, but whether this show actually proposed anything different from a typical biennial is questionable.

CCB: I think that one of the only ways you can beat the beast is to not deny it. In this age where everything is revealed, the only interesting sphere is what is invisible. The exhibition itself is the decoy and nothing has to be revealed: for me, that's the secret.

CT: Like a virus?

CCB: No, it's an agent. It is about shifting information for certain objectives. In art history, when the church's power was very strong, patrons commissioned an artist to do a fresco of the Virgin Mary, for example. Giotto, Masaccio or Fra Angelico did this but more—something else, something secret.

Today the self is being poached. It is so because of the large space occupied by the public sphere of politics, economics and entertainment in the global universe. There is a need that humans have—such as the freedom of the small gesture in daily life—that is slowly being eradicated by reality TV. The same is true of some relational art: many works speak about life but actually take space away from the self, because relations become part of an official discourse and a spectacle.

/ Carolyn Christov-Bakargiev

Michael Rakowitz, *Michael McGee's paraSITE shelter*, 2000. Courtesy the artist and Lombard-Freid Projects, New York.

Edgar Allan Poe was interested in *secrets*, and there are many purloined letters in the art world—but they aren't discussed, because they haven't been experienced publicly. Javier Téllez navigates the beast with his installations and Mike Rakowitz with his plastic houses for the homeless, which may never be an art project. Once involved in the gallery system, the artist must survive, but I try to find artists who make decoys/parallel artworks. Tiravanija established a community in Thailand of people who create things/props that are useful, not commodities. I believe that the best artists are touching on the cultural need for finding a space for the self.

 CT: At the art fair in Torino that piggybacked the Triennial, I noticed a work by Pascale Marthine Tayou—a heap of dirty socks. "Very difficult to purchase," I prodded. "Oh, if you like his work," replied the gallerist, "let me show you Pascal's crystal African masks." Illustrating your point, Carolyn. [Note: Pascale now incorporates glass heads within his installations.]

CCB: Yes. In the Middle Ages, art was in service of the church; the decoy was the church and the artist was exploring the construction of knowledge. The dialogue was an esoteric one of which the church was unaware.

 CT: This church art was also unsigned.

CCB: And so the artists were explorers in the realm of the *invisible*, and this is interesting to me. Today, we're living in a consumer culture where I believe the self has no space. The only thing of any importance is to find a way to be autonomous selves. So what does a curator do?

 CT: It appears that in this moment, the way we make exhibitions is

probably coming to an end. Some may see this as an opportunity for transformation. Ralph Rugoff is curating a show about invisibility. Do you think it is possible to do a show about this?

CCB: If I were to do a show about invisibility, I would do a show with the material, physical object as a decoy, and I would not say the show was about invisibility.

CT: For your show, you created a network of correspondents—ten young curators, most under thirty-five...

CCB: Their youth makes them sensitive to the Pantagruel syndrome. They grew up with overload and are thus tuned in to this affect. Sophia Hernandez said that the overload of experience in and out of exhibitions leads to the study of boredom.

CT: —boredom as a consequence of excessive stimuli?

CCB: The Stendhal syndrome refers to a story about Stendhal who, after a heady trip to Santa Croce in Firenze, fainted and lost touch with reality; it is also like the way a newborn baby falls asleep when shocked.

CT: Adam Szymczyk said that to avoid excess, he curates only solo shows. Instead of the supermarket, he says, you go *only* to an apricot farm—it's a way to address the beast. Raimundas Malasauskas from Vilnius proposed that every edition of this Triennial could be held with the same artists and the last show would be with the last survivor, like a solo exhibition in Death Valley.

CCB: It's interesting to note that his vision would end with a solo exhibition.

CT: The biennial, in its traditional form or not, benefits art communities outside the more traditional international zones.

Kathryn Smith, a South African curator, Gridthiya Gaweewong from Thailand and Joseph Backstein from Moscow each refer to their countries' thirst for the dialog international exhibitions present.

CCB: That's the other positive side of things; the exhibition, as opposed to a fair, is still a space where people try to organize elements in a meaningful way and to dialogue with others.

CT: And, by introducing the works of younger, lesser-known artists, the exhibition shows what is bubbling to the surface.

CCB: It is also about geography and age. Young people working in far-off places participate in the dialogue of these shows, and you learn from them. Globalization is decentralization, and that's the good side. Hans Ulrich Obrist employs a Boetti strategy, providing simple rules to produce a kind of chaos, and another order arises. This is creative curating; taking over the creative side too much, the curator may seem to become the artist and the artworks may seem to be illustrations of his or her idea, but in reality, the curator is playing a game, creating a *decoy* which may seem protagonistic but is actually a a device, a magic trick to keep the interface between the world at large and art in a state of positive misunderstanding.

CT: At the Triennial, most of the artists, like Abraham Cruzvillegas or Tamy Ben-Tor, were lesser known than Murakami and Salcedo, whose inclusion seemed like two solo exhibitions. What was this about?

CCB: These two mid-career artists were chosen as the slower moment of concentration. They are opposite to each other and suffer from the Pantagruel syndrome in different ways.

(left) Abraham Curzvillages, *Patriotismo (Patriotism)*, 2004. Courtesy the artist and kurimanzutto, Mexico City.

(above) Tamy Ben-Tor, *Hitler Sisters*, 2005. Courtesy the artist and Zach Feuer Gallery, New York.

/ Carolyn Christov-Bakargiev

Salcedo presents a silent, heavy abyss that speaks of the impossibility of the monumental, of centers of detention and the impossibility of travel and communication. It is the dark side of globalization and an anorexic digestive-system metaphor of the Pantagruel syndrome. She concentrates on the themes of imprisonment, displacement and grief in the contemporary world while exploring the territory of violence and its relationship to politics.

Murakami unites historical analysis and his sociological interests with the superficial style of today's consumer cultures. Through a pop strategy using new technology, he celebrates and questions, focusing on the constant flux of information, the speed of perception and communication, the hybridization of signs, and the high and low. He is the bulimic character in the play.

Salcedo celebrates the individual gesture. Murakami exposes the loss of the individual. She is the celebration of life. He is the airport culture.

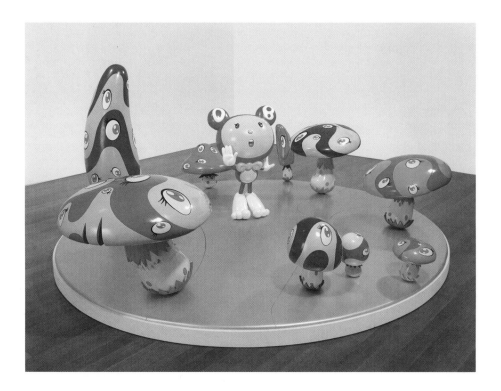

/ Carolyn Christov-Bakargiev

Takashi Murakami, *Dob in the Strange Forest*, 1999. Courtesy the artist.

/ <u>Carolyn Christov-Bakargiev</u>

Doris Salcedo, *Abyss*, 2006.
Courtesy the artist.

/ **Rirkrit Tiravanija**
Interview 2007

Rirkrit Tiravanija, *Untitled 1992 (Free),*
1992–2007, installation view, 2007.
Courtesy David Zwirner, New York.

CT: Born in Buenos Aires in 1961 of Thai parents, you've since chosen to live mostly in New York City. As both a curator and an artist, your installations take the shape of architecture or structures for living and socializing—rooms for cooking and sharing meals, reading, or playing music. As open-ended social experiments, they engage the public to test the boundaries of the work, questioning the nature of the institution while working within it.

Now we're sitting in your installation at David Zwirner's street-annex gallery, *Untitled 1992 (Free)*—an indoor/outdoor restaurant with self-serve curried cuisine. It's the ghost of one you did at 303 Gallery in the early 90s. And adjacent to us is a revived construction, *Open House*1 by Gordon Matta-Clark, the founder of the once-famous SoHo restaurant FOOD.

To present new works that hinge on earlier ones, or to rephrase an earlier work, is a topical practice today. What's your take on this activity?

RT: I personally think in *layers*, perhaps as nostalgia for the old days but also to fuel ideas about maneuvering in the present. History is important, and young people are not so aware of Matta-Clark or of my work, for that matter.

CT: In the 70s, certain artists were making art as a stance against materialism. Perhaps today's nostalgic rephrasing of that period emanates from a feeling of impotence—or a yearning for an art once perceived as a commentary on social change.

RT: Well, today, absorbed by capitalism and commercialism, even activism is like a business.

1. Matta-Clark's work is "a makeshift shelter built into a standard steel dumpster, whose space is divided by salvaged walls and doors into three or four interconnected chambers, each big enough to house a single sleeping body. The trash bin as homeless shelter" (Abraham Orden, "The Minute," *Artnet Magazine*, http://www.artnet.com/magazineus/reviews/orden/orden4-5-07.asp). Made to function—physically and conceptually—both Tiravanija's and Matta-Clark's artworks critique the value of art and commercial real estate.

/ <u>Rirkrit Tiravanija</u>

(above, left)
Rirkrit Tiravanija, *Untitled 1992 (Free)*. Installation view at 303 Gallery, New York. Courtesy the artist and Gavin Brown's enterprise, New York.

(above, right)
Gordon Matta-Clark, *Open House*, 1972–2007. Recreation of the original *Open House* between 98 and 112 Greene Street, New York. Courtesy the Estate of Gordon Matta-Clark and David Zwirner, New York.

CT: An integral part of your process encourages audience engagement... It's as if yours isn't a formal exhibition, rather a gathering of people. That you also scorn objects in favor of real-time experience conveys the sense that you're undermining consumerism—a Buddhist notion of non-attachment?

RT: Of course.

CT: In 1999, at the 48th Venice Biennale, in place of a Thai Pavilion, you planted a tree in the Giardini. Within eyeshot of the opulent American Pavilion, its proximity amplified its trickster stance.

RT: Szeemann had selected me for the *Aperto* and asked what I wanted to do. As there was no Thai Pavilion, I asked if I could plant the tree as a gesture to represent a pavilion. And yes, you could say that I chose myself as the curator; but to clarify, the Venice Biennale is the Olympics of the art world, a Eurocentric colonialist model where, in the Giardini, only first- and second-world pavilions are presented. The last pavilion built there was in 1999 for Korea, a very powerful country at that time—now it's China, (and they probably own Venice). The Italians don't want anyone else to build a pavilion, but if you have enough money to shove under the table, a new pavilion will rise.

Obviously, my planting a teak tree to represent the Royal Thai Pavilion was as an act of subversion, and when the tree grew large, the Italians chopped it down. (I wasn't paying for the space, and so the Italians couldn't allow it.)

CT: In 2001, Jens Hoffmann posed the question, "Should Documenta be curated by an artist?" What would you say to this?

RT: I've always been both artist and curator, and I see that for an artist to curate always brings a different methodology and perspective.

CT: Two major exhibitions, each co-curated by an artist, Manifesta 6 and *Saigon Open City*, ran into political problems, and each was canceled.

At Manifesta 6 in Nicosia, the central project was to build an interdisciplinary art school, to hold conferences and lectures and to publish a book. The scheme went off track when the curators insisted that the school operate in both the Turkish and Greek Cypriot sectors. Nicosia is a place where barbed wire is an everyday reality and the local politics are risky. In the end, one of the curators, the artist Anton Vidokle, tried to deal with the politics without taking sides, but if such a thing were possible, then Cyprus would not be a place where people have to show their passports to cross the green line. Finally after much friction between the curators and the city-run nonprofit sponsor, Manifesta 6, *Nicosia for Art*, was canceled.

In 2006, *Saigon Open City*, curated by Gridthiya Gaweewong and yourself, was also canceled.

RT: Vietnam is similar to China, where certain kinds of art may be booming; however, free speech does not apply. The Saigon Biennial was not a government-initiated situation. It was an idea dreamed up by the Saigon Biennale organization, a board of artists, writers and an art dealer from Ho Chi Minh City, Mae Do. However, Hanoi, in the north, is where the foreign cultural exchanges reside: Goethe House and Alliance Française had each supported this program, as did the Ford Foundation, and a balance was reached with the contingent in the south—to be rewritten with the north and south clearly defined.

The artist Dinh Q. Lê from Saigon stepped in and asked Gridthiya Gaweewong to be regional curator, and invited me to provide an international perspective. Doing a Biennial in this country is not just about filling a space with artwork and inviting people to visit. Platforms and some education were needed to enable local people to understand its presence as well as for the community to possess it for themselves. (At the first Gwangju Biennale in Korea, a million people showed up but had no idea what they were looking at; they came for the spectacle.) We wanted this Biennial to be a long-term project, and so we divided it into manageable proportions and invested in training a director, a registrar, electricians and installers.

CT: What prompted you to take on this enormous enterprise?

RT: To build something from scratch interests me. However, the $100,000 budget barely covered half the electricity bill, and so despite having only 50 artists, we couldn't pay them. Anyway, chapter 1 (completed) was designed around the history of the French occupation.

We have to demonstrate our national identity, our capacity, our ability.

It was a big problem; a lot of things got censored, parts of the venue were never open, but all the players dealt with these realities. Unfortunately, even though the plans for the Biennial organization had been in place for two years, it failed.

CT: Do you find comfort in knowing that you laid the foundation?

RT: Well, I wish it were better laid. We should have had more time to educate and explain the artworks so everyone would have felt better about the exhibition. Finally, we had a good core, but having to deal with a naive institution in a politically bureaucratic environment was disastrous.

CT: Despite the original approval of the project by the Vietnamese government, ultimately they removed it from its website. Why?

RT: On the one hand, the cultural ministry in Hanoi had put information about the exhibition on their website, and it was in the official pamphlet of the APEC meeting the month before. On the other hand, they couldn't decide whether to give us support. They told us to set a date for the opening, the announcements went out, we had people and journalists coming from everywhere who saw the show even though it hadn't officially opened, and when it finally did, it was for one month only. The official opening license arrived a month after it closed, and it was then that they censored things. The irony is that much of the work had already been seen. The Ministry of Culture reviewed all art, all printed words. The Vietnamese art (70 percent) was the core, and the other works would form a dialogue in terms of an outside context. Our approach was to concentrate on Vietnam and the local region and expand out from there. We were dealing with limited funds, time and a huge bureaucracy. But now we have experience, and we're hoping one day to do parts 2 and 3. However, as of now, all future segments have been officially canceled.

CT: Perhaps your success lies in your courage to take on challenging projects and to actively question the roles that the artist/curator plays in society.

In his book *The Three Ecologies*, Félix Guattari says, "We have an erroneous conception of ecology, of environmental struggle," and that we can effect enduring change only by broadening our views to include what he calls an ecosophy, three ecologies of the social/cultural and the natural environments.

(above)
Dinh Q. Lê (in collaboration with Hai Quoc Tran & Danh Van Lê; video in collaboration with Tuan Andrew Nguyen & Phu Nam Thuc Ha), *The Farmers and the Helicopters*, 2006. Courtesy the artist.

(facing page)
Superflex, *Supergas*, installation photo from *The Land*, Cheing Mai, Thailand. Courtesy of Superflex.

/ Rirkrit Tiravanija

One could say that your approach to a project such as *The Land* reflects Guattari's ecosophy. Beginning in 1998, you and Kamin Lertchaiprasert created and funded a large-scale collaborative and transdisciplinary collective on a plot of land in the village of Sanpatong, near Chiang Mai, Thailand. As a laboratory for self-sustainable development, it tests a new model for art and living that functions as the merging of ideas from different artists to cultivate a place of and for social engagement.

RT: Yes, it's a self-curating, self-run program originally inspired by a discussion I had with Jorge Pardo, Philippe Parreno, Liam Gillick and Maria Lind in Stockholm. Upon returning to Thailand, I reconnected with a friend/artist, Kamin, who was simpatico with my enthusiasm for creating an eco-systemic think-tank retreat for artists. Kamin found the property and became co-founder of this eight-acre site now called *The Land*.

CT: How did you get the funding?

RT: Originally, we funded 70 percent ourselves, but now there are friends who contribute. We don't fund-raise, we don't think in bureaucratic terms, we simply want a free, open space where people can come, commune, and build things. The landscape itself is based on a self-sustaining, holistic Buddhist garden where today there are meditation huts for artists to share with friends, who may then stay on to build one of their own.

The procedure is to live communally, beginning with a ten-day silent meditation, to travel to different communities and to acquire knowledge. A Buddhist farmer lives nearby, a sort of agricultural philosopher who has laid out a balanced method of cultivating land.

In Thailand, we have no museums, no galleries, no system to encourage or enable art collecting, and so it is often the case that young artists after art school become craftspeople, copy paintings, or make decorative objects. At *The Land*, Kamin instituted a one-year project that provides a platform for younger artists to dialogue, work and develop their practice.

Now, we would like to step back; we feel the project should not be so

/ <u>Rirkrit Tiravanija</u>

(left to right)
Canal dredging at *The Land*, 2007.
Agricultural meeting at *The Land*,
2008. Organic garden at *The
Land*, 2007. All courtesy The Land
Foundation.

dependent on us. Presently, there are ten sustaining members and we're asking artists who've passed through to make a flat work for auction so we can build new studios for visiting artists, meditation structures and temples and expand our agriculture.

CT: Who are some of the participating artist visitors?

RT: Tobias Rehberger and Philippe Parreno have funded and built little houses where anyone who stays in them leaves things behind for others. Superflex created a pendulum system for generating gas. We had no running water, so we pumped a well; one must discover new or old ways to live and to deal with the everyday. A group of Thai artists are building a water-filtration system, and some students are researching the idea of macro-climate, growing plants on a small plot but yielding maximum sustenance.

Part of the original concept for *The Land* was to lay a cultural and artistic foundation based on the idea of working as an artist through culture, agriculture and meditation, and of giving something back.

/ <u>Rirkrit Tiravanija</u>

Francois & Philippe Parreno, *Battery House*, 2003. Courtesy Friedrich Petzel Gallery, New York.

/ **Joseph Backstein**

Interview 2005

<u>CT:</u> The theme for the first Moscow Biennial in 2005, *dialectics of hope*, was a play on the irony of a utopia never found in communism and now lost to the pressures of capitalism. How did this idea evolve?

<u>JB:</u> I once read a book of that title by Boris Kagarlitsky written in 1980 about the history of different movements on the left after the war. I like the title—it has a very Russian feeling, implying that things may change in the future. It's not a dialectics in the Marxist term but in a more everyday sense; an important term for my generation, because Marxism was the only philosophy we were taught.

<u>CT:</u> There is also a kind of romanticism in this title, and as we've had ongoing discussions about your growing up in Russia during communist times, can you explain how your personal history is entwined?

<u>JB:</u> I was born in 1945 in Moscow to a poor Jewish family. We lived with another family in a communal apartment without a toilet or a bath and—except for a stove—no heating system. My mother was a biologist, and my father ran a small business. In 1944, during the war, my father contracted encephalitis, and when I was 14, he died. During that time, especially through 1953, when Stalin died, anti-Semitism was rife in the Soviet Union. I was able to survive by developing a double mentality that allowed me to believe I was born in the best country in the world, an ideological paradise—but at the same time, a kind of hell. I found a similar phenomenon in George Orwell's *1984.*

<u>CT:</u> What or who influenced your involvement in art?

<u>JB:</u> I attended the same high school as Alex Melamid, and we became good friends. I learned about art from his family; his father was a professor, and his mother was a well-known translator of German into Russian. They had a five-room apartment, which was luxurious for Russia, and I spent every other day with them. Alex then went to the art school, the Stroganoff Institute, and after that he started Komar and Melamid.

The country was so isolated that we couldn't get any books or magazines: foreign friends, journalists, diplomats, would bring them in from elsewhere. It was a difficult time; we couldn't call foreigners from home, only from a public phone on the street. In 1972, I first saw Komar and Melamid's art projects, and I found them interesting, so I wanted to know what was on Alex's mind. My comprehension of contemporary art and culture became clearer through our endless conversations, which lasted for years—until 1977, in fact, when he left the country.

<u>CT:</u> What was your first venture into the art world?

<u>JB:</u> I began writing about art, and in 1973 I met and became good friends with Ilya Kabakov. We had many discussions and wrote many books. For years, we made recordings of our conversations—we now have a huge archive of them, which Ilya used in a catalogue raisonné of his installations.

<u>CT:</u> Were you engaged in any other work at this time?

/ <u>Joseph Backstein</u>

(previous pages)
Yang Fudong, *Seven Intellectuals in Bamboo Forest Part 1*, 2003. Courtesy Marian Goodman Gallery, New York.

JB: I had a background in computer science, which I didn't find so interesting. I then studied sociology of art and culture, first on my own and then in a postgraduate program at the Institute of Sociology, where I wrote my dissertation and earned a PhD.

In those days there were only state institutions, in which I worked for 17 years. I became a curator in 1987. Under Gorbachev it had become possible to organize exhibitions in different venues, and a friend of mine was the director of an exhibition hall near Moscow. We organized a club of underground artists, several generations including Ilya and about 20 others. Then there was my first show in New York that Ronald Feldman helped me organize at P.S.1, called *Perspectives of Conceptualism*, which had several venues.

> CT: In 1991, the Institute of Contemporary Art in Moscow was launched as an independent, non-profit organization—an initiative by several Moscow artists and critics (including yourself) to represent the alternative movements of Russian art through the 70s and 80s.

JB: That is true; I wanted to say that as an independent curator I also organized many shows in Moscow from 1987 on. My first show abroad, in West Berlin in 1988, was called IsKUNSTvo Art International. It was a cultural shock—I was invited by the university in Bielefeld and came to West Berlin by train. I realized I didn't have a German visa; at that time, Soviet people didn't need a visa for East Berlin, which was a Soviet occupation zone, but we couldn't go to the rest of Germany. I went to the police and showed them the invitation and asked for a visa, but they told me to go to all three authorities, English, French and American, because the city was divided into sectors. It took a week to collect permissions, and they gave me a visa. It was a visa to Germany issued in Berlin—the irony of history. I went to Bielefeld and then to Frankfurt for an opening at Porticus for Ilya Kabakov.

> CT: What was your motivation to do a Biennial?

JB: Discussion of a Biennial in Moscow had been going on since the 90s, but financially and organizationally it was impossible. A few years ago by chance I became the Deputy Director for Contemporary Art at the State Center for Museums and Exhibitions ROSIZO—it's a strange abbreviation from Soviet times. Victor Misiano and I were both Deputy Directors in charge of this state institution, and we started to think that it would be very important for the country to have a Biennial; we don't have a contemporary art museum, and the institutional art world in Moscow and St. Petersburg is very weak. We also have a very conservative system of art education, still a very Soviet infrastructure, and so we needed to do a big, important project to modernize the situation. After a couple of years we were finally able to convince the Ministry of Culture to do it, and they gave us a budget of 2.5 million.

/ Joseph Backstein

<u>CT:</u> Were you able to support new commissions?

<u>JB:</u> It was very tricky. We had no basic management or structure; it was an adventure, a challenge.

<u>CT:</u> What persuaded you to invite an international board of curators to join you on this Biennial?

<u>JB:</u> Victor and I knew we couldn't do it ourselves; as a profession, the Biennial curator must know what's going on around the world. To have a board was to help legitimize the project to the Ministry of Culture. And so, for the first time we were able to invite the top professionals in our field and employ them—this has never happened before.

<u>CT:</u> How do you think the artists here in Russia will be affected by the international works?

<u>JB:</u> I think the Biennial will help legitimize contemporary art and culture in this country.

<u>CT:</u> A unique history exists here. Surely you don't want to homogenize Russian art with international art.

<u>JB:</u> No, we don't. What is important, however, is how the global and local connect. And so we invited important international curators to be on the board: Daniel Birnbaum, Iara Boubnova, Nicolas Bourriaud, Rosa Martinez and Hans Ulrich Obrist.

<u>CT:</u> There is a point of view that biennials are a means of colonization by the Western world in the field of contemporary art. Aren't you afraid of this?

<u>JB:</u> The phenomenon of globalization is important for Russia because, having once been an isolated superpower, it means reintegration into the global society. Another goal of the Biennial was a parallel reintegration of the Russian art world into the international art world. The task is to present Russian art in the international context and present international art in the context of contemporary Russian art, but without destroying the local myth.

<u>CT:</u> That's part of the problem with using this universal visual language in different countries: how can it express the local yet interweave a global context?

<u>JB:</u> The specific position of Russia in this process is unlike non-Western countries such as China and Turkey. The main historical problem of Russia is its European identity, which is confusing; either Russian culture is about European culture or it is just a marginal part of European culture. Historically, the Russian intellectual world has been divided between people who think they're Europeans and others who think as Russians, not Europeans or Asians, unique and special. Thus is the paradox of the Soviet Union: on one side was European philosophy, Marxism, and on the other was Stalin and isolation from the European world. It's always a problem of identity. At the same time, going back to colonization as a phenomenon—in Russian history we have self-colonization. In cultural terms, the Soviet Union was

many national republics, and official Soviet culture tried to colonize local cultures.

CT: Isn't that still a problem today?

JB: The main difference for this country now is that Russia does not have civil society. Power goes from the top to the bottom; there's no initiative from the people. Civil society is a mechanism to help you express your needs, defend your rights. Our court system is corrupt; law and property are not clear in this country. My theory is that this goes back many centuries, when Russia was colonized by Mongolian tribes, nomads—even the term *czar* is Mongolian. There were endless wars between Mongolian tribes and Russian kingdoms, and Moscow eventually inherited the power of this Mongolian empire.

The Mongolian culture bequeathed the absence of property and absence of civil society, with military administration and the army as the main social institution. Many think that Peter the Great modernized the country, but our theory is that he destroyed the last chance for Russia to set up civil society. Peter superficially modernized Russia; it looked like Europe, the aristocracy spoke French, but serfdom became stronger.

CT: How does this history fit into the Biennial context?

JB: I think contemporary art has a democratizing effect. The Biennial was administrated by the Ministry of Culture; money came from the state—that's why it's had such an impact. It will help to liberate, democratize and make society more tolerant. For me, it's not just an interesting curatorial project; it's my duty—I must do this for my country.

CT: The opportunity to educate and enlighten artists, curators, critics, administrators, politicos, collectors and potential philanthropists is one not to be missed. However, a recent article in *The Art Newspaper* reported, "Moscow's Alexander Sokolov, Minister for Culture and Media, and Andrei Kruzhilin, a culture ministry official, have announced that the 2,100 state museums and cultural institutions face imminent closure because the government cannot fund them." Furthermore, I learned that the average wage in these institutions is just 50,000 rubles [$1,800] a year. Although it's been proposed that the private sector be encouraged to patronize the arts, there are no tax concessions or laws to cultivate this. How were you able to support this new project without private sponsorship?

JB: For me as a curator it was a very interesting project because it seemed so impossible!

Finally, I was personally impressed by 3,000 people attending the opening.

CT: Let's talk about choosing the artists—what was the nature of the curatorial collaboration?

JB: Each of us proposed and discussed our obsessions and then the artists were selected by consensus.

/ Joseph Backstein

CT: Carlos Garaicoa and Cao Fei are both artists from Communist countries—they're marvelous choices for your audience here in Moscow. They bring a sense of their own history and the history of those in similar situations.

In Garaicoa's *Greatcoat*, four glass vitrines containing multiples of Soviet stamps overlaid with imagery from Cuban propaganda billboards, murals and graffiti were placed in a long corridor of the Lenin Museum. Garaicoa sees Cuba as the last link to communism's inefficiency, protocol and repressive behavior. Not only did the artist have difficulty bringing the work through customs, but also one of his Norwegian installers was drugged, beaten, robbed and abandoned in the cold. For Garaicoa, this was a confirmation of his convictions.

Cao Fei, a young artist from Guangzhou province in China, presented a well-staged installation that consisted of a video and many small, identical sculptures of Mao. With this piece, she is working through a history embodied by her parents and a stepfather, who were official sculptors in China.

JB: Russians think about their Soviet history with a certain ambivalence. We still have a Communist Party that tries to monopolize the subject, and when younger artists do certain works that are not politically comfortable, they try to ignore it. Also, we have a very uncomfortable relationship with our own art history and particularly with political history.

Today, people here don't think of the Soviet Union as a terrible dream; rather, it's more of a simple reflection. On the one hand, no one cares about the Soviet Union, yet on the other, it's fashionable to show Soviet films on TV. Soviet films are so much more acceptable now because they

Carlos Garaicoa, *To Transform the Political Speech in Facts, Finally*, 2005. Courtesy the artist and Lombard-Freid Projects, New York.

have more human, international values, as opposed to films produced today, which are extremely brutal.

> CT: I think this is bogus—it was a brutal time. Aren't you romanticizing Soviet society? In this Biennial, surrounding the Schusev State Museum of Architecture, projects by the internationally renowned artists Christian Boltanski, Michael Rovner and Bill Viola allude to the brutality of many countries, including the USSR, where in one way or another many were made to disappear.

JB: You're right. It's one thing to compare political and cultural life in the Soviet Union with Russia today. It's another to speak of the artistic products. If you compare Soviet films to those made now, maybe you could tell me the same thing about American films?

> CT: Regarding the videos inside the Museum of Architecture, I returned with Constantine Bokhorov, a Russian curator, to see Yang Fudong's *Seven Intellectuals in Bamboo Forest*. It is a complex film that combines nostalgic elements with a strong structural style, investigating how this dreamlike environment affects the intellectuals' relationships and discussions, as well as their solitary meditations on individuality and liberty. I sat between Constantine and an unknown woman, with whom he discussed the film in Russian. He was impressed that while she couldn't understand the spoken language or the subtitles of the film, she comprehended its spirit and structure.

JB: Yes, the Yang Fudong is a masterpiece.

> CT: Back at the Lenin Museum, the quite popular Russian artists group, the Blue Noses, installed a video in one of their series of cardboard boxes: a simulacrum of Lenin writhing about in his tomb. (The tomb sits right outside the Lenin Museum.)

JB: There seem to be ambivalent opinions about the Blue Noses. Although they are very popular here, their ethno-clichés exploit Russianness: presenting a subject they think represents Russianness but from a Western

/ Joseph Backstein

Cao Fei, *Father*, 2005. Courtesy
Vitamin Creative Space, Guangzhou.

point of view. Many of my colleagues think the same of Shirin Neshat's work.

Yeah, the figure looked like Lenin, it was like an illustration of the idiom "Lenin turning over in his grave." Alexi Kalima's work also exploited a Chechen theme. Since he was born in Grozny, the capitol of Chechnya, he feels he has the right to exploit that political issue.

CT: Terrorism combined with the question of the object was a tactic for David Ter-Oganyan's *This is not a bomb*. It was made up of 18 different bomb-like devices scattered throughout the Lenin Museum. The work refers to the fate of the institution and the impending disappearance of the formal object. In my country [USA] a bomb squad would have confiscated this, no doubt... and this is an irony of history.

JB: The Lenin Museum was a great venue because we could do whatever we wanted. It will be renovated soon, and it is now the subject of a big fight. It once belonged to Moscow City Hall, but now it seems that it will become a branch of the Historical Museum. After the Biennial, who knows what will happen!

CT: Is there an idea for a new museum or curatorial institution in Moscow?

JB: Well, no. There's currently no university for artists or curators—we have no institutions—and for curators, there are no jobs. If you're involved in art, you're in a museum or you're a dealer or gallerist. An independent curator has no place; very few people could survive by raising money. Because of my age and maturity, I have clear and stable attitudes, my own ways and mission. I'm not so dependent.

CT: How do Russian artists perceive certain aspects of their own art heritage, such as the icon?

JB: It's ambivalent because today, the icon isn't the problem; it's the church. During Soviet times, it was suppressed, but now it has become a very powerful institution. Several curators have had problems and scandals, and their shows have been destroyed by the religious authorities.

CT: What about the Russian experiments from the 1920s?

JB: Nobody cares. They were discussed in the 70s, but at that time Malevich wasn't shown in the museums, unlike now. The underground showed an

/ Joseph Backstein

Michal Rovner, *More*, 2003. Courtesy PaceWildenstein, New York.

interest in that period—and an ambition to continue it.

CT: At one time, some post-Soviet artists adopted the Soviet propagandist art style while others, with their newfound freedom, used pornography, sex and/or violence to shock—Oleg Kulik, for example. Is there a new post-Soviet style?

JB: No, no, we are post-post-postmodern now and it seems that there is no major style. How can we speak of a style in the era of globalization? We do expect individual artists to express local sociopolitical issues, but at the same time it's difficult to get into that subject.

CT: For this Biennial, it's important to understand Russian art of the last 30 years, which is why you have all these satellite shows, the Special Projects. And so you have brought the international to the local. Frankly, it would have been a disaster if they were omitted. I have another question, Joseph: Why hold the Biennial in Moscow in the winter? Even Napoleon and Hitler couldn't make it into Moscow in the winter.

JB: Well, it's an interesting brand. Venice is a hot biennial; Moscow is a cool biennial. Of course, it's difficult, but it's a difficult country. I think i t's a good idea.

/ Joseph Backstein

CT: It has been only 15 years since the mainland's first gallery opened, yet with so much international interest in new Chinese artists, the gallery scene in Beijing can seem up for sale to the highest bidder.[1] You are a prominent player in this rapidly expanding scene: an independent curator, an art historian, a golfer, an art dealer and one of the first, along with your partner, Waling Boers, to open a commercial gallery in mainland China: Universal Studios at Caochangdi in Beijing.

You were born and educated in the official Chinese art world, then in the 90s you became a critic, documenting the rise of the contemporary Chinese painters who have commanded big dollars at international auctions. What has been your personal experience of this rapid development of contemporary art in China?

PL: For me, it all began with my father. He was self-educated in art; his dream was to become an artist. Unfortunately, in 1949, he was imprisoned and my family was totally crushed. After this, he became a worker in a factory. In the 70s, when the government changed its attitude, he went back to school and, even without an initial degree, he got his master's degree in art history and taught at the Beijing Central Academy of Fine Art. The 1980s marked the beginning of Chinese contemporary art; it was the first time artists experimented with performance and conceptual art. New art magazines introduced both international and local art to a broader audience. Frankly, many people were surprised that the government would allow these activities.

Prior to Tiananmen Square, my father, Pi Daojian, supported the new art magazines and was among the first generation of scholars to follow contemporary Chinese art. In those days, artists congregated at our home in the evening to discuss ideas and philosophy. I was a young and impressionable middle school student and soaked up everything. Following Tiananmen,[2] my father was criticized and the magazines were shut down.

CT: I would imagine that the Tiananmen event was a great influence on a young person. How did your career unfold?

PL: It was natural that I would be immersed in art history, but my father encouraged me to study economics or media. Nevertheless, I studied at Beijing's Central Academy of Fine

1. Stacey Duff, "Beijing Art," *Theme Magazine*, Issue 15, June/July/August 2008, http://www.thememagazine. com/indexed/bejing-art.

2. The end of the Cultural Revolution in 1977 and the ultimate rise to power of Deng Xiaoping was perhaps the most important political event in Asia in the latter half of the 20th century. Under Deng, China began important trade and domestic reforms, but it also experienced the Tiananmen Square incident in 1989, where the government cracked down on pro-democracy demonstrators. It would be two years before the economic restructuring resumed, igniting an unparalleled creative and entrepreneurial spirit among Chinese artists.

Mathieu Briand, *SYS*018.DoE*01/ MoE-FIT\ SalNor*TaC-LaR, 2003,* Le Monde Flottant, Palais de Tokyo, Paris. Courtesy the artist.

Arts, graduating in 1996. Before the 90s, most artists could work only as teachers in universities; there was no art market to speak of. In '94, while I was writing criticism of contemporary art and cultural issues, two pioneering commercial contemporary art galleries opened, Red Gate and Courtyard. Courtyard offered me a job as assistant director and eventually sent me abroad to study at the Contemporary Art Center of Glasgow. Glasgow had a strong alternative and artist-run scene, and being there made me think about opening a non-profit art space in Beijing.

CT: What happened when you returned to China?

PL: I quit my job at Courtyard and became an independent curator. Then, in 2001, the Japanese curator Fumio Nanjo invited me and seven other young curators from Asia to create a show, *Under Construction*, and to collaborate on contemporary Asian art exhibitions in Seoul and Tokyo. The Japan Foundation sponsored the project and supported our travel (which extended to include India and Thailand). When back in Shanghai, I was offered a teaching job just around the time of the 3rd Shanghai Biennale, which was curated by my former professor at the Central Academy, Hou Hanru.

CT: I understand that this Biennale was a benchmark event for you.

PL: This show was a revolutionary project in that it was the first to include both global and Chinese contemporary art. Since then, the government has incorporated contemporary art in its cultural programs and asks professionals to curate shows. It has become clear, however, that such events serve propaganda purposes. One show for which I was an assistant curator, *Alors, la Chine (How about China)*, at the Centre Pompidou in Paris in 2003, was a troubling experience. We had been asked to curate an official exhibition, but the French museum officials treated the artists arrogantly, ignored the curators and censored proposals containing naked bodies or violence. The exhibition that emerged, although beautiful, was replete with exotic political coatings confirming the French imagination of China rather than representing the real Chinese perspective.

CT: It seems that the French hadn't learned much from the 1989 exhibition *Magicienes de la Terre*, also at Pompidou, which brought together art from the once-marginalized regions of the world. It could have been construed as a corrective to the *Primitivism* show in 1984 at the Museum of Modern Art in New York, but it bypassed what was truly modern in third-world cities in favor of a Western notion of the "authentic." Though flawed, *Magicienes* was nonetheless seminal.

PL: In 2004, I was further dismayed when I co-curated, with Hou Hanru, the exhibition *Fifth System*, a biennial of public art in Shenzhen in South China to which we invited major artists, ones whom we had worked with before: Olafur Eliasson and Rirkrit Tiravanija. But since we had only a small budget from a local museum, we were unable to raise the money for their fees and the entire show was canceled.

CT: Second-guessing the relative ethics of someone in your position, with multiple roles of critic, curator and gallery owner, might represent a hypocritical Western bias. Yet China has new rules for old Western games, and perhaps a desire to be in the lucrative loop of the new Chinese art market might tempt one to test the limits of certain professional practices.

PL: Well, one of the reasons I came to open a gallery, Universal Studios[3], is that I lost faith in large institutions such as biennials and art fairs. These exhibitions were not about art but were instead entertainment devices for the public. My impetus came also from the Chinese government's policy of funding *official* art but ignoring local art organizations. When I first met my partner, Waling Boers of Berlin's Buro-Friedrich Gallery, we exchanged ideas and decided to open a non-profit gallery. The non-profit idea was squelched when we realized a *non-profit* must be registered and requires a 15 percent tax. Furthermore, the market had become so prosperous that the value of artworks would increase several times within a very short time after their initial purchase. Also, I had worked with and nurtured so many artists only to see them commercialized and, very soon after they became famous, move on to contract with other commercial galleries. Our first gallery was in the 798 district in Beijing, but we soon moved to our present space, a huge renovated warehouse with a ten-year lease. Today, Universal Studios has evolved into a project space in which we curate exhibitions and invite

3. Now called Boers-Li Gallery. Representing China's hippest artists, the gallery is currently located outside the city and includes a café where artists and art people convene for drinks, eats, smokes, discussions and karaoke.

Olafur Eliasson, *The Weather Project*, 2003. Installation view at the Tate Modern, London 2003. Courtesy the artist, Tanya Bonakdar Gallery, New York, and neugerriemschneider, Berlin. Photo: Jens Ziehe.

/ Pi Li

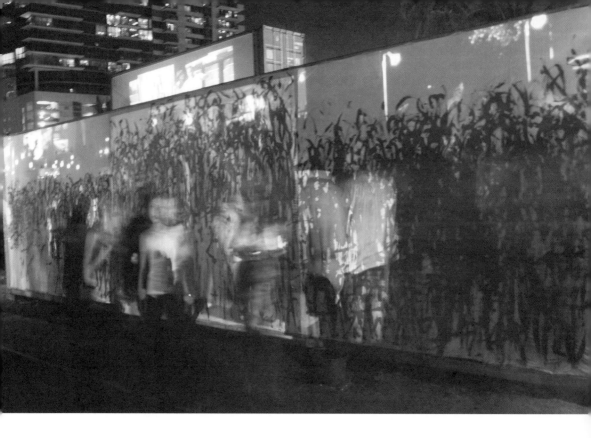

others to organize shows. We also sell to important private and institutional collectors.

 CT: How were you able to fund the first gallery?

PL: In 2004, I took one year off to produce the film *Shanghai Dreams*, for which I won a substantial award at the Cannes Film Festival. I planned to commit myself to film, but somehow the award disappointed me; I began to realize that the China the world wanted to see was not the one that I knew. Instead, I took the money and invested it in a gallery with Waling Boers, who was funded by the Mondrian Foundation—a Dutch organization with which he had previously worked. However, as they are now devoting their funds to artists from their own country, we have lost their support.

 CT: You are now [2006] one of the curators, with Lev Manovich and Yuko Hasegawa, for the current installment of Media_City Seoul, titled *Dual Realities*. This exhibition, hosted by the city of Seoul, is a public event that seeks to integrate new technologies with contemporary trans-disciplinary art. What has been your experience?

PL: First of all, I believe that the convergence of art and technology has brought a danger to art, as the viewer's attention shifts to technology and odd visual experiences, and the artist's technological requirements come

/ Pi Li

Liu Ding, *Tracing the Wind and Shadows*, 2006. Installation view at Grace Li Gallery's Positions section of Art Basel Miami. Courtesy Pi Li and Boers-Li Gallery.

to obscure his conceptual and critical agenda. On the other hand, the Internet and multimedia have become part of our lives; the physical world and virtual reality are now closely interrelated and integrated. *Dual Realities* approaches a new physicality with an artistic language of diverse and creative ideas.

> CT: Has the curatorial team considered support from the corporate world for new-media experimentation?

PL: Today, most Asian cities consider media or digital art as a new creative industrial/commercial movement, one that incidentally involves film, graphic design, video and industrial design. In this new moneymaking industry, Samsung, Sony and other computer companies sponsor artworks as a form of advertising.

> CT: So the companies gain from the artist's experimentation, and the artist has the opportunity to use their equipment and facilities without charge...

PL: I think most Asian companies, such as Samsung and Sony, support art as a way to dress up their products. In 2000, when Hans Ulrich Obrist and Barbara London curated the first Media_City Seoul, it was quite a spectacle. I was influenced by your interview with Barbara in your book, *Foci: Interviews with 10 International Curators*, in which she talked about the Fluxus media artist Nam June Paik, whose work was purely art-oriented. We (the curators) liked this idea and took on a low-tech approach, one

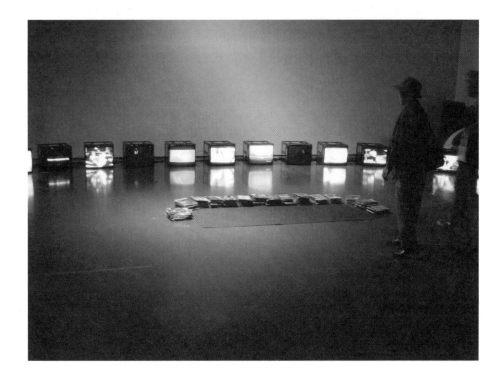

Yan Jun, *3000 DVDs*, 2006.
Courtesy Pi Li. Photo: Xu Ke.

that emerged from the artist and made interesting connections. Also, our budget was only one million dollars; former budgets were more than ten times that amount.

CT: For me, what was interesting about the first Media_City Seoul in 2000 was the opportunity to see how new media could bring about changes in our thinking about exhibition spaces. Instead of a petrified model, architects, directors and curators are recognizing the outer surface of the museum as a new discursive arena to accommodate this cultural change, expanding audiences and new technologies, such as they have at the Schaulager in Basel, New York's Museum of Modern Art and Creative Time in 2007.

/ Pi Li

(above)
Timothy Jaeger and Alex Dragulescu, *Respam*, 2005. Courtesy of the artists. Photo: Sonia Paulino.

(facing page)
Mathieu Briand, *SYS*O18.DoE*O1/ MoE-FIT\ SalNor*TaC-LaR, 2003,* Le Monde Flottant, Palais de Tokyo, Paris. Courtesy the artist.

Can you talk about some of the artists in your show and how they relate to the theme?

PL: Lo Din, a very young artist, did a performance for the opening. He projected footage from a video camera onto a canvas or wall and then quickly painted these scenes with brushes and fluorescent paints. As the performance continued, the impossibility of his efforts was captured in unbroken time, becoming a massive, roughly drawn and entangled landscape painting. Yan Jun addresses the prevalence of cheap, pirated DVDs in China. Yan collected 3,000 DVDs and brought them to the exhibition, where visitors could choose among them for free. There are also 20 monitors playing illegal DVDs, set up in such a way that the videos' music, dialogue and special effects could be experienced simultaneously. Timothy Jaeger + Alex Dragulescu's *RESPAM-inbox* (2005) is an audio-visual performance. It's an Internet art platform for the collecting, implementation and cultural integration of unwanted abject data such as spam e-mail solicitations. It highlights the idea that spam threatens to turn the once-utopian cyber-landscape into an abyss of junk mail. Matthew Briand examines the way that humans recognize and accept stimulation using various technologies such as computers, electronic music, robotics, visual effects and lasers. When visitors enter the room containing his installation, they find themselves in a space that creates the illusion of being inside a virtual-reality simulation program. Actually, the effect was made by filling the room with a five-centimeter-thick layer of talcum powder illuminated by a green laser.

CT: In this exhibition, and others, did you include any of the artists you represent at Universal Studios? A tricky question but also, under the circumstances, don't you think you have to be especially careful when curating exhibitions, considering the multivalence of your practices, the other hats you're wearing?

PL: Yes, I don't think we should hide this connection, but now I have stopped curating major exhibitions and devote my time to the gallery.

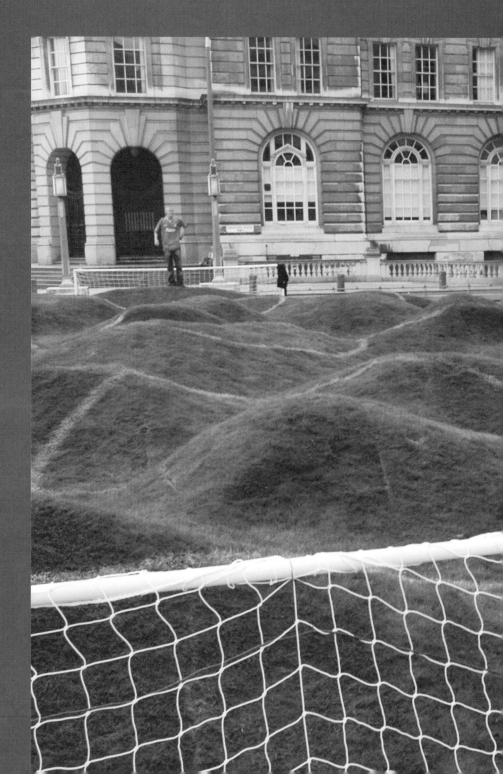

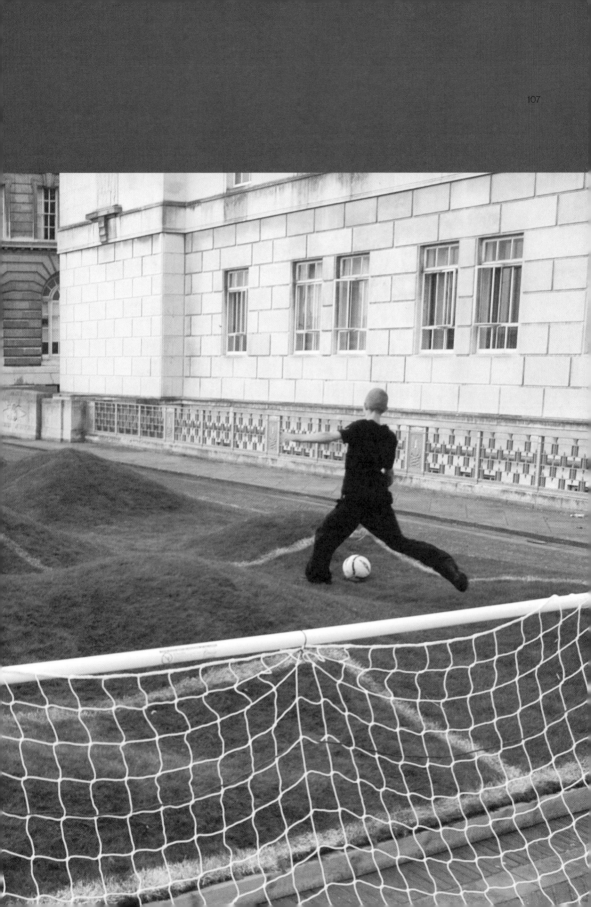

CT: Under the pressures of globalization, a great number of contemporary art events, self-supporting exhibition spaces and collectives have been developing in Latin America and other regions. In some cases, in order to negotiate the lack of traditional institutional infrastructures, the local art community tends to experiment with more flexible and inventive solutions to create new networks.

VPR: We are in an age of multiple artistic centers, and thanks to frequent travel, communication, and exchange of images and information on the Internet and other media, the relationship between localities is becoming increasingly interactive.

I was the Director of MADC, the Contemporary Art and Design Museum of Costa Rica, from its opening until the change of government. Prior to that, I was an artist and traveled quite a bit. My studies in French literature got me a professorship for ten years until I became fed up with bureaucracy and returned to Costa Rica and dedicated myself to my art.

I began working with objects, assemblage and installation work, for which I won first prize at the Sculpture Biennale in Costa Rica. When I was invited to direct MADC, my career as an artist was just stabilizing. I thought to myself, "You complain about museums not operating the way you thought they should and art institutions not responding to artists' needs, and here they're offering this opportunity." And so I took the job to see how I could change things, but this lasted for only five years.

I had had plans with another curator-artist to open an alternative space in Costa Rica. He had just returned from serving as curator of contemporary art at San Francisco MOMA. He was also involved with the Yerba Buena Art Project. Although Nicaraguan by birth, he came to retire in Costa Rica. We had long planned to open an exhibition space but didn't know where or how to get the funding. I invited him to be my co-curator and tried to make the space not only for exhibitions but for cultural reference as well.

CT: For a long time, Latin America has been concerned with the experience of boundaries, and transcending them. How identities form, prove themselves and transform, shifting, changing, some even vanishing, then forming anew. Whether one is dealing with physical matter or with information, it is a time of uncertainty. Thus the work of contemporary artists speaks not only from a specific place but also from their condition of transience; their context is no longer a place (a country) but the contact zone where different cultures meet every time they stop in their routes.

So in your case, when you say "cultural reference," do you mean the specific culture of Costa Rica or of Latin America?

VPR: I meant to put Costa Rica on the map! I also wanted to change the stereotype of Central American art, which was then considered exotic,

/ **Virginia Pérez-Ratton**

(previous pages)
Priscilla Monge, *Soccer Pitch*, 2006, installation view, The Liverpool Biennial. Courtesy Galeria Juana de Aizpuru, Madrid.

commercial or otherwise. Every time I visited a biennale, there was either no single Central American artist present or, if so, it was a disaster. At that time (around 1994), the shows that were coming out of Costa Rica and other Central American countries were considered decorative or safe.

I don't formulate my work only around identity, but by referring to the museum as a place of culture, I'm referring to its mission: to go beyond the role of simply organizing art shows, and to integrate our artists into a larger circuit; taking the Costa Rican artist outside of the comfort zone and promoting exchange with foreign artists.

> CT: In an article titled "Questions on Place and Space in Latin American Art," Maria Clara Bernal Bermudez wrote, "Every generation reinvents itself and in this sense what we see is that within the journey into globalization art proposes a paradigm to survive homogenization as well as complete fragmentation and isolation and that is the strategy of negotiation of space and place."[1]
>
> How is the identity issue dealt with in Costa Rican art?

1. Maria Clara Bernal Bermudez, "Questions on Place and Space in Latin American Art," *LatinArt.com: An Online Journal of Art and Culture*, October 1, 2005.

VPR: Costa Rica became independent in 1821—most of Latin America became independent in the 19th century. Costa Rica has a very funny relationship with its own identity, one that is not discussed because it is assumed not to have one.

Like all of Latin America, there were the nationalist schools and the schools that taught values linked to the countryside and to the labor of the fields (this was in the 1930s). Costa Rica was pretty much the same as other Latin American countries in the sense that they all had schools founded by conservatively trained Europeans, and for many years they conveyed only European aesthetics and values. When a younger generation came on the scene, they wanted to create a new aesthetic linked to Latin America.

> CT: Racially speaking, however, Costa Rica is one of the most homogenous (European) when compared to other Latin American countries.

VPR: As you know, the Spaniards killed off many of the Indians in our countries, but some have persisted through the centuries. The Caribbean cultural critic and writer Eduard Glissant talks about three kinds of Americas: the New America, Meso-America and Euro-America.

"Meso-America" is not only the anthropological Meso-America—the southern part of Mexico through Costa Rica—but also includes countries like Bolivia and Peru, where there are large populations of Indians.

In Costa Rica, the indigenous culture constitutes only 7 percent of the population, and they live in the mountains in poor conditions. In Guatemala, there's an indigenous culture that co-exists with the culture brought in by

the Spaniards, and both feed off each other. The religion that the Guatemalan Indians practice is a synchronism between Catholicism—from the colonizers—and their own religion. Every country has a different mix.

It is different from the Caribbean, where entire indigenous populations were killed off and replaced by people from Africa, Germany, France and the Netherlands. Glissant calls this the New America.

> CT: I'm curious about the connection between Costa Rican artists and their own country. Have the schools shed their formalist teaching or is there more of a mix or collaboration, such as you just described with anthropology?

VPR: The art schools are still completely Euro-American-oriented—the art and art history being taught is from the 1950s. But now, the new generation of artists in Central America is more informed, employing many of the strategies that any international artist would use, but with a strong relationship to their own geographic context.

> CT: I was reading an essay by the Cuban artist Wilfredo Lam, who referred to the Cubist use of African art as an inversion/subversion, a structure that, in his own work, he attributes back to Cuba, in the African style.

VPR: The sabotaging of modern movements is a strategy among many Latin American artists. The curator Katja Garcia-Anton spoke about how pop art, minimalism and conceptualism, when taken by Latin American artists, are perverted and subverted—(although conceptualism is a more political gesture).

Priscilla Monge, a Costa Rican artist, makes work that is serial, with all the formal characteristics of minimalism, but with a different, more humorous intention. For example, she made boomerangs out of marble. Monge was one of the artists that Gerardo Mosquera invited to the exhibition called *Perverting Minimalism*.

> CT: You've said that there are many female curators in Latin America. What is the relationship of the curator and the artist to feminist principles, and how did the feminist movement come about in Central America?

VPR: In Central or Latin America, feminism has had a variety of takes. In Argentina, the feminist movement has been quite strong for many years. In Central America, affected by many years of war and a very *machista* mentality, women fought to participate in politics and dedicated themselves to establishing their own authority. In the last few years, feminism has gathered a lot of strength, but because of our multiple identities and character, each country in the region addresses it differently—just as we deal with life in general. Even in the early 90s, whose generation of artists was made up mostly of men, there were female artists who were making powerful artwork.

Due to the new laws of equality, a growing percentage of women are

involved with and affected by the feminist movement. The workplace is full of women, and this is true in the arts as well. Priscilla Monge's work has a feminist reference and attitude. She works with the ambiguity of partnerships, stating that no one is free of guilt and that a victim is in some way an accomplice to the victimizer. Patricia Belli, from Nicaragua, deals with her own deformity. She has congenital alopecia and has been dealing with the trauma of growing up bald in a conservative society. In her artwork, she takes this personal issue and mixes it with Nicaraguan politics. Paulo Herkenhoff saw her works and those of Marisel Jiménez, a Costa Rican artist who also had a traumatic childhood. When he saw their craft-rag dolls and wooden sculptures, he felt that they had much in common with Louise Bourgeois. In Guatemala, Maríadolores Castellanos, Diana de Solares and Elena Torabuerta all deal with the types of relationships you establish in a conflicted context like Guatemala, but not all of their artworks use politics, and many deal with intimacy.

> CT: You spoke at the conference organized by Harald Szeemann at P.S.1 about art and terrorism, violence and violent places.

VPR: When living in a violent context, artists produce art that deals with this—a different kind of art from the *arte denuncia* of the 70s and early 80s, which was pamphletary and basic. The art produced now is much more subtle and indirect, such as the works by Colombian artists José Alejandro Restrepo or Oscar Muñoz. Each creates very powerful things dealing with violence and the disappeared in Colombia.

Oscar Muñoz's *Breath* consists of six to ten stainless-steel mirrors onto which the artist has silk-screened images of vanished persons. Their images become visible only when your breath hits the mirror—the condensation from your breath repels the grease in the ink, causing the photo to appear. When the condensation stops, the photo becomes invisible again.

> CT: The work of the Brazilian artist Brígida Baltar, *Collecting Mist*, where she performs the inevitably frustrating gesture of trying to capture something that is immaterial, is part of this context, of grasping an issue that has the element of change in its nature.
>
> You also spoke about certain Latinos growing up with violence in Southern California who were arrested and then deported to their country of origin.

/ Virginia Pérez-Ratton

Oscar Muñoz, *Aliento (Breath)*, 1995.
Courtesy Oscar Muñoz and Sicardi
Gallery, Houston.

VPR: Yes. In the US, those who become ruffian gang members are imprisoned and sent back by the planeload to El Salvador and Honduras, where some go to prison while others end up on the streets or return to their villages. The problem is, they are still connected to their gangs and drug-dealing networks in the States. Ironically, many don't even speak Spanish. Along with the American support of corrupt regimes in Central America, the local situation is lacking in opportunities for work and education—producing mass migrations to the US. It's a grim and vicious cycle.

All of Central America is in chaos: Salvadorians, although very industrious and demonstrating great economic growth, are impeded by the inequitable distribution of wealth. It's like it was before the war; those who have the money have all the power, and for those without money there is less opportunity. With the population growth, drug trafficking and money laundering, the drug lords have more money than the governments.

Nicaragua has 65 to 70 percent unemployment, and people are actually dying of hunger. There was a terrible drought in Matagalpa, where the coffee crop was lost and the plantation owners said, "Sorry, we have no work for anyone." When I was there in July 2001, farm workers were marching 100 kilometers on foot to the capital to ask for help; the government tried to say that this was a Sandinista insurgency.

CT: I imagine that amid all this chaos, your art space, TEOR/éTica, is one where many curators come to get a grasp on the art and politics of Central America.

VPR: I founded TEOR/éTica in 1999, six months after I resigned my job at the MADC. I wanted to continue the work I was doing at the museum, but on a more theoretical level. The museum is a beautiful building with a specific function to fulfill. TEOR/éTica is a small house with a different budget and purpose; it has become a cultural center in San José, with exhibitions inside and outside the venue. We try to obtain support for artists, and our journal has been published 25 times in the past four years. There is a reading room and an arts library dedicated to contemporary art, design, photography and architecture; an archive of digital images and print reproductions of Central American and Caribbean artists; and a collection of about 6,000 slides of art from the region.

CT: Tell me about your project Estrecho Dudoso (Doubtful Strait).[2]

VPR: It is a visual-arts event organized by TEOR/éTica that took place in several venues—institutions and public spaces across San José and Alajuela, in Costa Rica. After almost seven years of intense work in the

/ **Virginia Pérez-Ratton**

(above)
Regina José Galindo, *Recorte por la linea*, 2005. Primer Festival de Arte Corporal, Caracas, Venezuela. Courtesy Prometeogallery di Ida Pisani, Milan/Lucca.

(facing page)
Federico Herrero, *Untitled*, 2002. Courtesy Sies + Höke, Düsseldorf. Photo: Achim Kukulies.

research and dissemination of regional contemporary artistic practices, TEOR/éTica is now presenting this large-scale event with the participation of over 70 artists from 28 countries.

The Prince Klaus Fund and the Ivos Foundation have supported us. The Rockefeller Foundation sponsored a symposium from which we issued a publication. In addition to my other tasks, I have to do fund-raising for everything.

CT: The concept of living in a world now connected in many ways brings to mind the situation of Federico Herrero, once a student of mine at Pratt, who returned to Costa Rica mid-semester because he felt his career was not making any headway in New York City. He was subsequently discovered by Harald Szeemann, who came to TEOR/éTica in 2000 to choose artworks for the Venice Biennale.

VPR: Yes, he went through hundreds of slides and catalogues and we took him around to the galleries and museums. He chose six artists: Priscilla Monge, Jaime David Tischler and Herrero from Costa Rica, and Aníbal López, Luis González Palma and Regina Galindo from Guatemala. Galindo and Herrero received prizes at the Venice Biennale.

Herrero now has galleries representing him in Peru, Düsseldorf and Madrid. None of this has gone to his head, though. When he returns from his traveling, he still locks himself up in his large studio in Costa Rica.

2. "*Estrecho Dudoso (Doubtful Strait)* is a large international event for the visual arts being held from 1 December 2006 through 15 February 2007 in Costa Rica. It is staged in museums, institutes and public spaces in San José and Alajuela. More than seventy artists, most of whom from Latin America, are participating.

The event coincides with the designation of San José as the cultural capital of Latin America 2006. Virginia Pérez-Ratton from the TEOR/éTica foundation dreamed of plans for an event of this size for quite some time. When Hivos approached her about organising a regional event within the framework of San José's appointment, everything fell into place. An event of this scope has never before been organised in Central America. The proposal was well-received internationally, resulting in participation and assistance from various museums, art collectors and organisations.

Estrecho Dudoso is dedicated to the artists Juan Downey (Chile, 1940–1993) and Margarita Azurdia (Guatemala, 1931–1998). Both made important contributions to the visual arts in Latin America. Two retrospective expositions of their work are presented. The event also boasts four collective expositions, each with its own theme and a specific location. The themes of the expositions are closely related, each melting with the next in a sense. The thread running through them all is the concept of borders. Geographic, political and symbolic borders. Borders in the broadest sense of the word. According to curator Pérez, the event reflects the world of today and the arts, including not only poetic works but also some with a political content. The event has the objective of looking beyond borders to strengthen the relationships between the various artists. 'In a time in which diversity is the primary theme of most projects, we want to work more from the similarities within that diversity. This could contribute to greater and better understanding of the work of artists in various places in the world'" (Lidy Norder, "*Estrecho Dudoso*: Costa Rica as the Epicentre of Visual Art," The Power of Culture, January 2007, http://kvc.minbuza. nl/no/current/2007/january/estrecho_ dudoso.html).

/ Virginia Pérez-Ratton

Joseph Backstein

was born in Moscow. He was the Artistic Director of the State Center for Museums and Exhibitions ROSIZO and the Director of the Institute of Contemporary Art in Moscow. He curated *Norman Foster: Space and Time* at the State Pushkin Museum of Fine Arts in Moscow in 2006, the second Moscow Biennial in 2007 and the first Moscow Biennial in 2005. Also in 2005, Backstein co-curated *Angels of History: Moscow Conceptualism and Its Influence* at MuHKA in Antwerp, Belgium. In 1999, Backstein was the curator for the Russian Pavilion at the Venice Biennale, where Komar & Melamid participated in a piece called *Collaboration with Animals*, in which monkeys and elephants created art. In 1997, along with Elena Elagina, Backstein curated *Collective Action* at Exit Art. He has written numerous books including *Secession: It's a Better World; Russian Actionism and Its Context* in 1997, *Body and the East: From the 1960s to the Present* in 1999 and *Angels of History: Moscow Conceptualism and Its Influence* in 2005.

Carolyn Christov-Bakargiev

has been named the curator for Documenta 2010. She was the curator of the 2008 Sydney Biennial and the Chief Curator at the Castello di Rivoli, Museo d'Arte Contemporanea in Turin, Italy. In 2005, she was a co-curator of the Turino Triennial: *The Pantagruel Syndrome.* A member of the 2001 Venice Biennale jury, Christov-Bakargiev has written extensively on Italian and international art for publishers such as Phaidon Press and SKIRA and is the author of *Arte Povera*, which was published in 1999. She was the curator of many Castello di Rivoli exhibitions, including *The Moderns* in 2003, *William Kentridge* in 2004, *Pierre Huyghe* in 2004, *Franz Kline* in 2004 and *Faces in the Crowd* in 2004–2005. Christov-Bakargiev was previously Senior Curator at P.S.1 Contemporary Art Center, New York, where she co-curated *Greater New York* in 2000 and organized group and solo exhibitions including *Around 1984: A Look at Art in the Eighties* in 2000, *Animations* in 2001 and *Janet Cardiff* in 2001. In 1993, she was a co-curator of *Antwerp '93*. She has written extensively on contemporary art and its relationship to postwar European art. Among her publications is the first survey monograph on Italian informal artist Alberto Burri, published in 1996.

Okwui Enwezor

is currently the Dean of Academic Affairs and Senior Vice President at San Francisco Art Institute. Enwezor has curated numerous exhibitions in some of the most distinguished museums around the world, including *Archive Fever: Uses of the Document in Contemporary Art* at the International

Center of Photography, New York, in 2008, the same year that he was
the director of the Gwangju Biennial in the Republic of Korea. Enwezor
was the Artistic Director of the 2nd International Biennial of Contemporary
Art of Seville, Spain, in 2006. He was the Artistic Director of Documenta
XI in 2002. Between 2001 and 2002, he curated *The Short Century:
Independence and Liberation Movements in Africa, 1945–1994*, which
traveled from Museum Villa Stuck, Munich, to Martin-Gropius-Bau, Berlin,
to the Museum of Contemporary Art, Chicago, and then P.S.1 and the
Museum of Modern Art, New York. Also in 2001, Enwezor curated
Century City at the Tate Modern, London, and *Mirror's Edge*, which trav-
eled from the BildMuseet, Umea Universitet, Sweden, to the Vancouver
Art Gallery, Vancouver, to Tramway, Glasgow, and the Castello di Rivoli,
Torino. In 2000, he was an art adviser for the 1st Echigo-Tsumari Art
Triennial in Japan. In 1996–1997, he was the artistic director of the 2nd
Johannesburg Biennial. In 1996, he curated *In/Sight: African Photographers,
1940–Present*, at the Guggenheim Museum.

Charles Esche

is the Director of the Van Abbemuseum, Eindhoven. In 2007, he co-curated
the 2nd RIWAQ Biennial, Ramallah, Palestine. In 2005, he co-curated the
9th International Istanbul Biennial with Vasif Kortun. In 2002, he was the
co-curator with Hou Hanru and Song Wan Kyung of the Gwangju Biennial,
Republic of Korea. Between 2000 and 2004, he was the Director of
Rooseum Center for Contemporary Art, Malmo, Sweden. He is co-founder
and editor, along with Mark Lewis, of *Afterall Journal* and Afterall Books,
which is based at Central Saint Martins College of Art and Design,
London, and CalArts, Los Angeles. Esche is also a theoretical adviser at
the Rijksakademie, Amsterdam. He has written for many art catalogues
and magazines, and selections of his texts were published in Turkish
and English in 2005 under the title *Modest Proposals* by Baglam Press,
Istanbul. Esche was one of ten curators included in Phaidon's internation-
ally recognized series devoted to contemporary art, *Cream 3*.

Massimiliano Gioni

is a curator at the New Museum of Contemporary Art in New York, where
he organized, with Laren Cornell and Laura Hoptman, *The Generational:
Younger Than Jesus* in 2009, and the Artistic Director of the Nicola
Trussardi Foundation in Milan. In 2006, Gioni, along with Maurizio
Cattelan and Ali Subotnick, curated *Of Mice and Men*, the 4th Berlin
Biennial for Contemporary Art. In 2004, he was a co-curator of Manifesta,
with Marta Kuzma. He was part of the curatorial team for the presentation
of the latest acquisitions of the Dakis Joannou collection in *Monument*

to Now in Athens in 2004. Gioni curated *The Zone* at the 50th Venice Biennial in 2003. In 2002, with Cattelan and Subotnick, he created the Wrong Gallery, a not-for-profit space in the Chelsea art district of New York. Merely three-by-three feet, the tiny space has hosted more than 40 shows, including Lawrence Weiner, Shirana Shahbazi, Tino Sehgal and Elizabeth Peyton. In 2001, the three founded the publication series *Charley*. Gioni was the editor of *Flash Art*, and he has written numerous articles and books on contemporary art, including pieces for *Parkett*, *Flash Art* and *Carnet*. In 2007, he published *Unmonumental* with Laura Hoptman, Richard Flood and Trevor Smith.

RoseLee Goldberg

founded PERFORMA in 2004, a non-profit, multi-disciplinary arts organization for the research, development and presentation of 21st-century visual performance art. As the director, she launched New York's first performance biennial, PERFORMA 05—a three-week program of live performances, exhibitions, installations, film screenings and symposia by more than ninety international artists. In 2007, PERFORMA 07 was greeted with even more critical and popular acclaim than the first. Previously, Goldberg was the director of the Royal College of Art Gallery, London, and a curator at the Kitchen, New York. She has curated museum performance series including, in 2005, *Couleurs Superposées: Acte VII*, a performance by Daniel Buren at the Guggenheim, New York, and in 1990, *Six Evenings of Performance* as part of *High and Low: Modern Art and Popular Culture*, Museum of Modern Art, New York. Goldberg has taught at New York University since 1987 and has lectured at Columbia University, New York, Kyoto University of Art and Design, the Mori Museum, Tokyo, the Tate Modern, London, the Whitney Museum of American Art, and Yale University among other institutions. She is an art historian, critic, curator and author. Her book *Performance Art from Futurism to the Present* was first published in 1979. She has also written *Performance: Live Art Since the '60s* (2004) and *PERFORMA: New Visual Art Performance* (2007).

Mary Jane Jacob

teaches at the School of the Art Institute of Chicago and is a member of the graduate faculty of the Center for Curatorial Studies at Bard College, New York. She has worked as an independent curator since 1990. In 2002, she was invited to the Spoleto Festival in Charleston, South Carolina, where she conceived and developed the *Evoking History* program, and she co-curated, along with Tumelo Mosaka, *The Memory of Water*. She specializes in projects that test the boundaries of public space and the relationship of contemporary art to audiences. Jacob has curated a

number of shows including *Conversations at the Castle* in Atlanta and *Points of Entry* in Pittsburgh, both in 1996; in 1993, *Culture in Action* in Chicago; in 1991, the site-specific exhibition in Charleston, *Places with a Past*. As a graduate student, Jacob curated a project called *The Michigan Art Train*, a six-car train that traveled across the country showing works from selected areas. After this, she moved into museums as a curator of modern and contemporary art before returning to her interest in public art. Jacob has also served as Consulting Curator for the Fabric Workshop.

Pi Li

is a curator, art historian, art dealer and art adviser. He has curated Media City Seoul 2006 in Seoul, South Korea; the *Fifth System* at the He Xiangning Art Museum in 2003 (co-curated with Hou Hanru); *Allôrs la Chine* at the Centre Georges Pompidou, Paris, in 2003; *Moist: Asia-Pacific Multi-Media* at the Millennium Museum, Beijing, in 2002; *Image Is Power* at the He Xiangning Art Museum in 2002; *Fantasia* at the Donga Ilbo Art Museum in Seoul in 2001; and *Future Hope* at the Tsingtao Sculpture Museum in 2000. He was the Assistant Curator of the Chinese Pavilion at the Bienal de São Paulo and the Shanghai Biennale, both in 2002. He is an adviser on Asian-Pacific contemporary art to the Tate Collection, curator for the Asian-Pacific region for the Artist Pension Trust, contributor to *Ice Cream*, the 2007 edition of Phaidon's noted *Cream* series, and Director of the 2006 Chinese Contemporary Art Awards. He now only curates for his gallery, Boers-Li (formerly called Universal Studios—Beijing), which he founded in 2005 with Waling Boers, and which supports individual creations in visual arts, design, film and music.

Virginia Pérez-Ratton

founded TEOR/éTica, a private non-profit project in San Jose, Costa Rica, dedicated to the research and dissemination of the artistic practices of the Caribbean basin. She has been the curator of *ev+a*, 2003, in Limerick, Ireland; a member of the International Jury for the 2001 Venice Biennale and the Panama Biennale in 1999; juror for the National Prizes in Visual Arts, Costa Rica, in 1987; and a Board Member of the Costa Rican Art Museum from 1986 to 1987. Pérez-Ratton was the first General Director of the Contemporary Art and Design Museum of Costa Rica, serving from 1994 until 1998. In 1992, she began to work as an independent curator and has since written numerous articles and catalogue texts, both for individual artists and for institutions. Topics she covers include globalization and regional art; the museum as a political, public and non-neutral space, its projection into the community, and its function as cultural reference; problems of the representation of regional artists; and the feminization of